*Paint your own
illuminated letters*

Paint your own illuminated letters

Stefan Oliver

Oceana

An Oceana Book

This book is published by
Oceana Books
The Old Brewery
6 Blundell Street
London N7 9BH

ISBN 1-86160-214-6

OCELYT

Project Manager: Rebecca Kingsley
Project Editor: Sally MacEachern
Designer: Wayne Humphries
Editor: Clare Haworth-Maden

Typeset in Weiss
Manufactured in Singapore by Eray Scan Pte. Ltd
Printed in Singapore by Star Standard Industries Pte. Ltd

Contents

Introduction

◆ ◆ ◆

Writing is an essential part of our culture. We need to be able to communicate with others by writing, to keep records of our own thoughts and to preserve calculations and information of all kinds. Perhaps more importantly, we need to be able to read what others have written, so that we can absorb their wisdom and knowledge, profit from their experiences and learn from their discoveries. We can take a book on any subject and glean information from it. We can take a work of fiction and be transported by the skill of the author into realms beyond our own imagining. We can read of thoughts and deeds committed to writing thousands of years ago.

All this is available to us because humans both learned language and devised ways in which to set this language down in a form that could be understood by others. It is true that there are many different languages spoken in the world, and that there is a variety of ways in which to set them down, but scholars can learn these different scripts and languages and then translate them so that ordinary people, who only need to know a language for everyday use, can read translations of anything that has ever been written, anywhere in the world. No doubt, computers will soon be readily available that will not only be able to transcribe spoken words, but will also simultaneously translate these words into any number of languages, so that all human knowledge and information will become universal.

Humans alone, of all creatures, starting from the first, primitive beings, had the intelligence to develop the most amazing ability to speak to each other, not only of the basic necessities of life, but also to express feelings and emotions and construct beautiful poetry. Not only did humans learn to vocalise these things, but they furthermore learned to write them down so that others could share their innermost thoughts and ideals. What is also astonishing is that people in various parts of the world independently but simultaneously developed their own different systems of speaking and writing.

THE POWER OF LANGUAGE

We probably all have an image in our minds of our early ancestors, their daily rounds of work done, seated around the fire in the dark of night, listening to tales of brave deeds, fierce battles, or of ancient myths and legends. Although listening, they had probably heard it all before. However, the words would be reinforced in their memories, and when they became too old to follow an active life they in turn would tell the stories to their families, thus playing their part in confirming the verbal traditions.

It would be nice to think that, as humans learned to write, these ancient tales and legends were written down, but this does not seem to have been the case, for it appears that the first efforts at writing were made to record transactions, and that writing was thus first used for the mundane ends of trade.

THE FIRST TYPES OF WRITING WERE:

• Picturegrams: these were the earliest symbols used as a form of writing to convey a meaning, and each stylised symbol represented a meaning by its image. By combining several together, it became possible to express an idea.

i) A bird and an egg may have meant 'fertility'.

ii) Strokes descending from heaven may have meant 'rain'.

• Ideograms: these evolved from picturegrams, and their symbols were used to represent ideas.

i) Crossed lines may have meant 'enemy'.

ii) Parallel lines may have meant 'friend'.

• Rebus: this further development came about when one or more symbols were employed to represent something with a similar sound. (This device later became popular in the Middle Ages for use as personal badges or emblems. Abbot Ramrydge at St Albans, for example, used a ram's head with 'rydge' written on its collar; Ashton had an ash tree growing from a ton; and Sir John Peché adopted a peach with an 'é' written on it.)

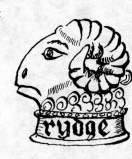

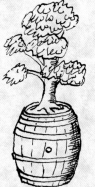

• Phonograms: once it was accepted that symbols could represent sounds, they became more stylised and their numbers were reduced. An alphabet began to emerge.

abc

The History of Writing

◆ ◆ ◆

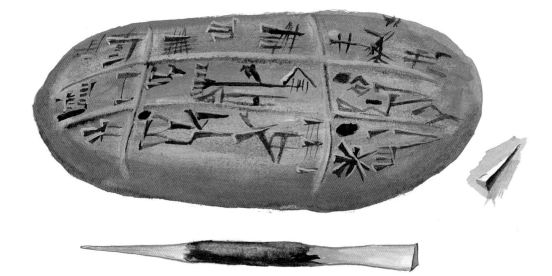

THE ORIGINS OF WRITING

As far as we know, the earliest forms of writing (which used some 600 symbols) are those that were discovered in the Middle Eastern region known as Mesopotamia, which stretched from what is today the Persian Gulf to Iraq. The examples that have been recovered appear to be accounts and tallies. The writings were made on clay tablets (when they were still soft) with a stylus that was probably made from wood, bone or dried reed. The stylus was pointed at one end and wedge-shaped at the other, and was used to make lines and wedge-shaped depressions in the soft clay.

By 2000 BC the Akkadians – the early ancestors of the Arabs and the Hebrews – by then the dominant power

DRAWING OF A CLAY TABLET, WITH A WOODEN SCRIBER, ONE END POINTED, THE OTHER WEDGE SHAPED SUCH AS WOULD HAVE BEEN USED TO MAKE THE CHARACTERISTIC MARKS.

DETAIL SHOWING THE WEDGE SHAPED MARK MADE BY THE BROAD END OF THE SCRIBER.

in the area, were using and developing a cuneiform script. When they were conquered by the Babylonians in around 1800 BC, cuneiform became the official writing system. The ability to write was not widespread, however, and a cast of scribes evolved which devoted its efforts to learning and writing the cuneiform system. The scribes became very powerful, for their literary skills meant that they wielded more power than their often

illiterate masters. This form of writing came to be widely used in the Middle East, and was adopted by other peoples, even if they spoke different languages.

EGYPTIAN WRITING

Over the same period, a different system of writing was evolving in Egypt. The Egyptian civilisation was highly advanced, and its system of writing was well in place by 3000 BC. The Egyptians regarded writing as a gift from their ibis- or baboon-headed god, Thoth. Their system of hieroglyphics comprised around 5,000 different symbols, and Egyptian scribes were very powerful and important people, because few would undertake the long training needed to master the complicated script.

HIEROGLYPHS

The word 'hieroglyph' means 'writing of the gods', and is derived from the Greek words *hieros* ('holy') and *gulphine* ('to engrave'). The system of hieroglyphs was mostly made up of three kinds of symbols: picturegrams, which are stylised drawings representing objects, with combinations of symbols expressing ideas; phonograms, which represent sounds; and determinatives, which are used to indicate what is in discussion. The names of gods and pharaohs were written in red pigment, or placed in cartouches (oblong shapes).

Hieroglyphs were mostly read from right to left, and this was indicated by the direction in which the heads of the creatures used as symbols were pointing. Because writing was considered to be the gift of the gods, the symbols were always drawn with great

PAPYRUS REED.

care and treated as if they were almost sacred in themselves. They were carved on monuments in stone and written with reed pens on scrolls of specially prepared papyrus.

PAPYRUS

The papyrus reed grows to about 2.5 metres (8 feet) tall, and the plant floats in great matted clumps, forming islands on the Nile. In ancient times the reeds were harvested, and those destined for the production of scrolls were split into strips. These were laid carefully beside each other and another layer was placed crossways over the top. These were then pressed, and because the natural gum in the plant would make all the strips stick together large sheets of flattened papyrus could be built up. These were stuck together to form long rolls, which were cut as needed to make up scrolls – some as long as 11 metres (35 feet) – for the scribes.

BOAT MADE FROM PAPYRUS REED.

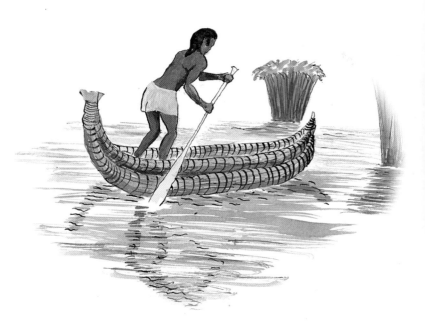

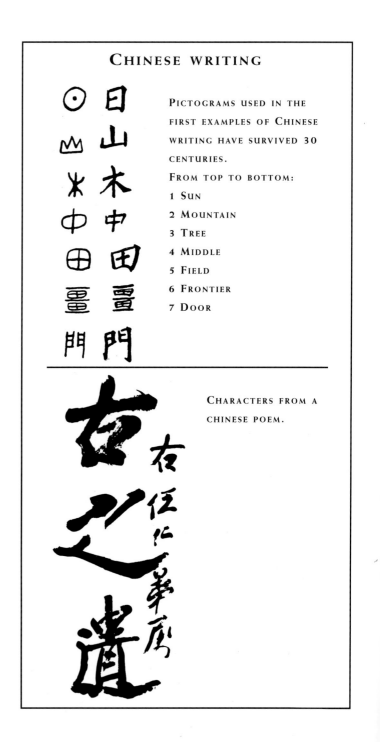

When writing, the scribe sat cross-legged, resting the papyrus scroll on a board over his knees. Unwinding and rewinding it as he worked, he wrote with a reed pen, dipping it in black and red ink contained in pots at his side. The black ink was made from water and soot, with gum arabic acting as a fixative, and the red from minium (red lead oxide) and water, as well as gum arabic.

SCRIBE SITTING CROSS-LEGGED, ROLLING UP HIS SCROLL AS HE WRITES, HIS INKS BESIDE HIS KNEE.

The Egyptian state had a monopoly over the production of papyrus and exported it all over the Mediterranean region, thus deriving a significant revenue from the reed.

THE HIERATIC SCRIPT

The drawing of hieroglyphs required great skill and was very time-consuming, and so a more cursive and flowing script gradually evolved. This was called 'hieratic' (from the Greek word *hieros*, meaning 'sacred') because it was originally used by the priests. In the first century BC a quicker system was developed, known as the 'demotic script' ('the writing of the people'), which subsequently became the prevalent script in use in Egypt.

THE CHINESE SYSTEM

Meanwhile, in China, another writing system was evolving – a system that has continued to be used up to the present day. It developed from pictograms and combinations, a stylised form of writing combined with phonetic signs which indicated the correct pronunciation of each group of symbols. The characters were originally written with a brush, which made thick, downward strokes and thin, upward strokes. It thus became necessary to write the strokes of the character groups in the correct order to avoid confusion. Such was the precision, and the degree of skill and care, needed, that beautiful Chinese writing became an art form in itself, one that was accorded the highest recognition. Even though the characters have hardly changed since they were first used 4,000 years ago, and can now be written with a pen or even a ballpoint, the art of the scribe is still esteemed as highly as that of any other decorative artist.

THE INDIAN WRITING SYSTEM

In the fourth century BC, a written language was already well established in India. Sanskrit – the language of the Indian gods – and Brahmi, which is the root of Hindi, were both in widespread use.

CHINESE WRITING

PICTOGRAMS USED IN THE FIRST EXAMPLES OF CHINESE WRITING HAVE SURVIVED 30 CENTURIES.

FROM TOP TO BOTTOM:

1 SUN
2 MOUNTAIN
3 TREE
4 MIDDLE
5 FIELD
6 FRONTIER
7 DOOR

CHARACTERS FROM A CHINESE POEM.

THE FIRST ALPHABETS

The writing systems that we have looked at so far relied on their ability to depict items, words and ideals by means of a symbol, and it was thus necessary to master a huge range of separate symbols in order to compose a sentence. It was not until around 1000 BC that the first rudimentary alphabet was evolved by the Phoenicians. These were a merchant people who had gradually spread across the shores of the western Mediterranean. They were a tough, adventurous race of traders, and it is thought by some scholars that they even travelled as far as England and India. Their alphabet spread with them, and it was from this that the Aramaic and Hebrew alphabets are believed to have developed. Both of these languages were used to write down the Old Testament, the ancient religious books of the Hebrew, and subsequently also Christian, religion.

By about 3000 BC the Greeks, also a trading people, had evolved their own alphabet, from which developed the Latin alphabet. Both of these included capital- and small-letter forms; the former was used for carving on stone, and the latter for writing on papyrus scrolls or wax tablets.

FROM THE THIRD CENTURY BC, LAPIDARY SCRIPT FLOURISHED ON THE MONUMENTS OF THE ROMAN EMPIRE.

THE SPREAD OF LATIN

As the people of Latium (the western-central Italian homeland of the Latin people) became the dominant power in the Mediterranean area and spread into western Europe, their language and alphabet went with them. They had a high proportion of literate people and writing was an important means of communication, and also of erudition and learning (from their own, as well as Greek and other civilisations' ancient classics).

The square, widely spaced capital letters that we can still see today carved on their monuments remain the largely unchanged basis of the modern English script. They evolved in that form because of the constraints imposed by the tools that were needed to carve them. However, when they were written with a reed pen on papyrus, it

was possible to inscribe them in a more relaxed, and less widely spaced, form. So developed the style later known as 'rustic' (a term applied to any artefact or artistic endeavour that displays a more relaxed and cruder execution than evidenced on its original exemplar).

THE INFLUENCE OF CHRISTIANITY

By the time of Christ, there were thought to be some 3,000 different languages in use in the world, only about 100 of which were written down. The life, teachings and death of Jesus Christ instigated a new religion – Christianity – one that would have a profound influence on the world and, indirectly, also on the history of writing.

Christ had instructed his followers to teach the Christian creed to all nations and peoples, so they accordingly set out to spread Christ's Gospel all over the world. The Christian missionaries were seen as a direct threat to the power of the Roman Empire and its gods, and they were therefore rigorously persecuted and suppressed, particularly by the Emperor Diocletian (215–313 AD). However, in 313 AD, the Roman emperor Constantine I accepted Christianity and was baptised. From then on Christianity was the official faith of the Roman Empire. Missionaries were now able to travel to the subjugated countries of the empire, taking with them the written accounts of the life of Christ, the Gospels and copies of letters (the Epistles) from prominent Christian leaders. They ventured far and wide, as far as Africa and India and possibly even America.

WRITING INSTRUMENTS

The Romans developed the use of parchment, folding and cutting it into the form that we would recognise today as a book. These volumes were much easier to handle than long rolls of papyrus: they were less bulky, far more durable, and it was much quicker to find a particular part of the text by referring to a page number than it was to hunt through a long scroll. Papyrus was too brittle to be used in book form, and could only be successfully employed as a scroll.

THE FIRST BOOK

THE SHEET OF PARCHMENT WAS CUT OUT OF THE WHOLE CURED SKIN AND FOLDED IN FOUR, EIGHT OR SIXTEEN ACCORDING TO THE SIZE OF THE BOOK TO BE PRODUCED. THE REMNANTS WERE USED FOR BINDINGS AND ALL KINDS OF OTHER USES. NOTHING WAS WASTED.

THE SKINS WERE FOLDED AND SEWN TOGETHER IN THE MIDDLE TO FORM THE BOOK. THE TOPS WERE SLIT WITH A SHARP KNIFE, TO SEPARATE THE PAGES. AS MANY OF THESE AS WERE NEEDED TO MAKE THE BOOK WERE MOUNTED AND BOUND WITH THICK PARTS OF THE SKIN AND GIVEN COVERS MADE FROM WOODEN BOARDS.

PARCHMENT

Parchment was made from animal skins – usually goat- or sheepskins. (High-quality vellum – its name derived from the Old French word *velin*, 'a calf' – was made from the skin of a calf.) The skins were soaked in lime and then stretched on a frame. As they dried out, they were vigorously scraped to remove the hair and fatty tissues. The skins had to be correctly cured so that they were both pliable and odourless. They also had to be carefully stored so that they did not go mouldy or curl.

When the scribe received his skins, he had to sort through them carefully in order to match them for colour and thickness. Before use, they had to be well rubbed with pumice or a cuttlefish shell in order to remove the animal grease. The outer side, on which the animal's fur had grown, was the tougher; though both sides could be used, care had to be taken to match the pieces cut for the pages so that the same side was used. The toughest, thickest part – from the centre of the animal's back – was often favoured to cover the boards that made up the binding.

QUILL PENS

Quill pens were found to be far superior to pens made from reed. They were more universally available, easier to prepare, capable of finer cutting and so offered cleaner results, and were also more durable. They did, however, dictate the styles of lettering that could be produced. Because they were cut into a chisel shape and thus had sharp corners that were liable to catch in the writing surface and splatter ink in all directions, in the main they could only be used successfully when forming a downward stroke. This drawing of the pen downwards, or to the side, gave the characteristic thick-and-thin ink line that, when carefully controlled and skilfully executed, produced letters of distinction.

UNCIALS

The Christian missionaries, spreading their creed northwards as they went, had to spend much time making copies of their sacred writings. The pressures of speed, and the limitations of their tools, caused the development of a new style of lettering: the 'uncial'. Uncials still comprised capital letters, but they were much rounder in form. There soon developed from these the 'half uncial', which was a small-letter form.

In order to write the letters properly, it was necesary to use a chisel-pointed pen, with the tip of the nib touching the writing surface parallel to the horizontal line formed by the bottom of the page. (Most people find this quite difficult, as the natural inclination with a chisel-ended nib is for it to touch the paper at an angle of 45° to the horizontal.) It meant that the scribe either had to master the art of twisting his wrist at an acute angle or that he had to tilt the page, with the attendant difficulty of keeping his lines straight and his letters upright, or else that he had to use a pen with the nib cut at a special angle.

THE DARK AGES

With the fall of the Roman Empire, its civilisation, laws, culture and arts were overrun and destroyed by a succession of invading barbarians who had no knowledge of, or interest in, such things. A tide of ignorance and destruction swept across Europe, and much that was learned was pillaged or forgotten.

THE INSULAR STYLE

In the furthermost corners of the former Roman Empire, however, which were remote from the ravaging hordes, religious works of great beauty were being produced in monasteries in isolated spots, notably in Ireland and the north of Scotland.

Removed as they were from outside influence, these monasteries evolved a style of lettering which later became known as the 'insular style'. This originally developed from uncials, but subsequently flowered into a script of angular complexity, embellished with intricate lacework and convoluted, swirling curves, incorporating strange creatures in its letter forms and decoration. Whole pages were covered with the most complicated and carefully worked interlacing patterns of ribands and creatures in a 'carpet' design. The initial page of the Gospels was formed and filled so that only the great capital letter and a short phrase were used. In the body of the text that followed, capital letters, picked out in green, yellow, black and red, often incorporating a weird and twisted creature, marked the start of paragraphs and verses.

THE DARKNESS RECEDES

As the ferocity of the barbarian invasions subsided, Pope Gregory the Great sent missionaries out from Rome into the rest of Europe again. These, too, took their sacred writings with them, which were still written in Roman capitals, large and small, though the rustic form was also used. In the seventh century, when missionaries from Ireland and Scotland moved back into England and then on to the continent, uncials, half uncials and Roman letters were all being used together.

With the crowning of Charlemagne as the Holy Roman Emperor in 800 AD., a new era of enlightenment dawned in Europe. Charlemagne understood the importance of reading and writing as a way of communicating, recording and learning, and set about doing all that he

UNCIAL LETTERS, WRITTEN ALWAYS AS CAPITALS.
HALF UNCIALS OR SMALL LETTERS WERE A LATER DEVELOPMENT.

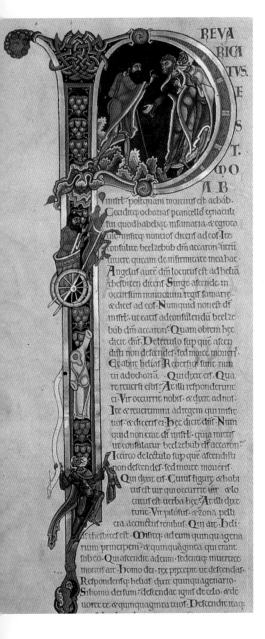

could to establish literacy in his dominions.

He appointed the English abbot of York, Alcuin, to run the court school at his capital, Aachen, and also made him abbot of the monastery of St Martin in Tours. Alcuin was given the task of revising the different styles of script that had variously evolved and of producing a standard hand to be used for the production of books. At the same time he was charged with reviewing all the texts then available and, with recourse to their original forms, removing any corruptions that had crept in over the years.

THE CAROLINGIAN STYLE

The style of writing that Alcuin developed became known as 'Carolingian miniscules', after its patron. This was a small-letter, or lower-case, form, using Roman capitals. It was a much rounder and more flowing hand, for use in the body of the text. Major capitals and those in the text were written in Roman capitals, and opening lines were inscribed in uncials, as were the capitals that began verses in the text. This style became the standard hand used in Europe until the twelfth century.

GOTHIC LETTERING

In the tenth century there began to evolve a form of writing that was more compressed and angular than the Carolingian style. It was quicker to write and took up less room on the page, so enabling economies in time and materials to be made. (In an age when there was an increasing demand for books that had to be painstakingly produced by hand this was a major consideration.) As the forms became more compressed and dense, the hand became known as 'black letter', but because it developed during the period that historians call the Gothic, it subsequently assumed that name.

The Gothic script evolved in several different forms, but the two main groups are 'Gothic textura quadrata' and 'Gothic textus pressius'. The former has diamond-shaped 'feet' on the straight letters and forked ascenders on the tall letters. This style could be written with the nib's tip at the more relaxed angle of 45° to the horizontal line. Gothic textus pressius has no feet or serifs (lines at the extremities of the letter) at the bottom of the straight letters and is written with the nib parallel to the horizontal line of the page. Both relied for their beauty on discipline to keep the tops of the letters perfectly level and all the upright, straight strokes exactly parallel to each other and the vertical line of the page.

CHANCERY SCRIPT AND ITALIC

In Italy there evolved two scripts: chancery and italic. The papal court, with its constant need to communicate across western Europe, developed its own style from the Carolingian miniscules, which subsequently became known as 'chancery script'.

As the demand for books of all kinds grew with the advance in learning, there evolved a humanist script that was even quicker to write, which we now call 'italic'. Book production had been almost entirely confined to the monasteries before then, but by the fifteenth century the clamour for books was so great that secular scriptoria ('writing rooms') were set up around the universities situated in the main cathedral towns to produce the wide variety of material required.

THE ADVENT OF PRINTING

The advent of printing – the invention of the German pioneer Johann Gutenberg (1398?–1468) – heralded the death knell of handwritten and hand-decorated books.

Type was made of wood, and later metal, and illustrations were cut into wooden blocks and then engraved onto copper plates (in our own time, photography has taken over this illustrative role). The manufacture of paper was developed at the same time to provide a suitable and cheap material upon which to exploit the new technology.

WOOD ENGRAVING

A block was prepared from specially selected and seasoned wood. Boxwood was found to be the best, and a carefully treated selection of wood of the same thickness as the type was chosen, cut across the grain, so that the artist worked on the end grain. The outline of the design was drawn onto the wood and the artist-engraver cut away the wood so that only those parts were left that were to be used to print in black. In doing this, a small tool called a burin was used, held in the palm of the hand so that the 'tooth' projected between the thumb and forefinger. Burins were made in a variety of shapes, and by careful manipulation the engraver could produce the finest of lines and the most skilfully executed blocks.

COPPER-PLATE ENGRAVING

Copper-plate engraving was executed with the same tools as used in wood engraving, but it was possible to produce much finer work through the application of half-tone shading created by the controlled use of fine dots struck into the copper. The whole text could be engraved onto the plate, allowing for a much more decorative style of treatment and saving the trouble of resetting the item in type.

A round and flowing script of great beauty was developed by engravers, which was assiduously copied throughout Europe, as it naturally evolved from the italic hand that had become universally popular. With a quill pen cut to a point, it was possible to imitate this lettering and, by increasing the pressure on the downward strokes, the points of the nib could be spread and thus a thicker line inscribed. By relaxing the pressure a thin line was drawn, and by careful application the most beautiful and convoluted swirls and curves, with elegant, thick-and-thin letter forms, could be produced. With the introduction of metal nibs, this style of writing became the norm, and earlier techniques were forgotten and lost.

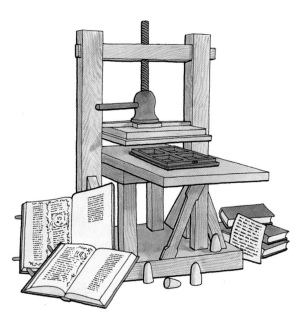

ABOVE: GUTENBERG PRESS SHOWING CONE SHAPED STAMPS FOR INKING THE PRINTING BLOCKS.

LEFT: A PAGE OF THE 'FORTY-TWO LINE' BIBLE, C.1455 TRADITIONALLY ASCRIBED TO JOHANN GUTENBERG.

THE REVIVALIST STYLE

At the end of the nineteenth century a movement emerged, led by William Morris, intent on rediscovering the arts and techniques of earlier days. He was repelled by the sterility and artlessness of the prevailing products of the time and therefore sought to revive the skill, expressiveness and elegance of earlier eras.

Influenced by the stimulus provided by William Morris, Edward Johnston, after much study, discovered how the artists of the medieval scriptoria produced their stunning works. He developed the 'book-hand' style, modelled on Carolingian script, from his research, and

this has become the basic script used by modern calligraphers. Following his example, and learning from his published works, a new school of calligraphers in Europe and the United States has today elevated the art to the heights of loveliness.

ILLUMINATED LETTERS

If you walk into the manuscript room of a museum, you will be stunned by the sumptuous richness of the volumes that are set out on display. Only when you have got over the initial shock of the first, dazzling encounter, will you start to take in the extraordinary detail, the convoluted strapwork, the intricate miniatures, and the astonishing and fantastic depictions of creatures of a bygone culture, displaying richness of imagination, strength and boldness of execution, confidence in faith and pride in a mastered skill.

ANONYMOUS MASTERS

Many of the earlier craftsmen remained anonymous, as they were usually monks who were working for the greater glory of God. With the establishment of universities, secular *scriptoria* were set up to supply the books for an increasingly

hungry clientele. Of these, more information survives, and some names have endured through the mists of history to be acknowledged as brilliant artists. Some artists, however, are only known by the place where they worked, like the 'Master of Egerton' or the 'Baucicout Master'.

AN EVOLVING STYLE

The use of colour with which to enhance capital letters and to draw attention to, and mark, different passages in the text was first practised by the ancient Egyptians, and later the Greeks and Romans. This convention continued for some ten centuries, the decoration becoming increasingly complicated, spreading from the capital letter to the margins and borders of the text, and filling every space with complex, linear decoration.

In this book I will explore a wide variety of capital letters taken from a selection of manuscripts that span the whole range of styles, from the earliest, simple, pen-drawn capitals, through the periods of flamboyant artistry, to the capitals carved on wooden blocks used in the first printing presses.

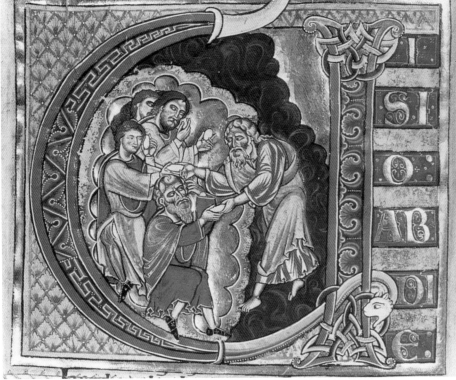

INITIAL LETTER 'V' VISIO ABDIE – THE VISION OF OBADIAH illustration shows Obadiah of I Kings 18, Winchester Bible.

Symbolism

❖ ❖ ❖

Flowers

♦ ♦ ♦

Flowers and foliage are the most commonly used decorative subjects in humanity's attempts to render the utilitarian, decorative. Their diverse forms have been depicted both realistically and in formal stylisation.

When you consider the amazing abundance and variety of flowers, as well as their beauty, colour and construction, it is small wonder that they have been used in this way. The amazing variety of leaf shapes, too, in their cool shades of green, have such elegance and symmetry that it is not surprising that they represent some of the oldest decorative forms known.

Flowers and foliage are thus a very common element in the decoration of capital letters and page borders. In earlier works it was common to find them represented in stylised form, but by the end of the fourteenth century they were being rendered with greater realism. By the sixteenth century botanical illustrations were appearing, complete with dew drops and realistically drawn fruits, berries and insects.

CHOICE OF FLOWERS

What influenced earlier artists in their choice of flowers is not known, but there are many possiblities. The most obvious is simple preference. Another is symbolism: it may be that the flower was a badge of the household or even featured on the heraldic achievement of the recipient. It could also have been the emblem of a patron saint or have had some other personal meaning.

THE MEANINGS OF FLOWERS

Over the centuries individual flowers have come to symbolise specific meanings. To the medieval mind the message conveyed by the flower would have been as real as a written one and, to the illiterate, more intelligible. But note that even if we think we can discern a message symbolised by the floral decoration of a manuscript we may be making an enormous assumption in believing that this was intended. However, it is worth noting some of the better-known flowers and their symbolic meanings for future use when planning your own projects.

THE MEANING OF FLOWERS...

EMOTIONS

Agrimony – thankfulness.
Aloe – grief.
Anemone – forsaken.
Balm – sympathy.
Basil – hatred.
Bird's foot trefoil – revenge.
Carnation, pink – a woman's love.
Carnation, striped – refusal.
Carnation, white – disdain.
Campanula – gratitude.
Chrysanthemum, red – I love.
Chrysanthemum, yellow – slighted love.
Elderflower – compassion.
Forget-me-not – true love.
Gorse – love in all seasons.
Lavender – mistrust.
Lime blossom – conjugal love.
Myrtle – wedded love.
Orange blossom – marital love.
Lobelia – malevolence.
Love lies bleeding – hopelessness.
Marigold – pain and grief.
Mint – suspicion.
Pear blossom – lasting friendship.
Periwinkle – remembrance and lasting happiness.
Moss rose – confession of love.

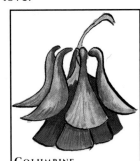

COLUMBINE

Rose, red – love.
Rose, yellow – jealousy.
Rosemary – remembrance.
Rue – regret.
Snowdrop – hope.
Tulip, red – declaration of love.
Tulip, yellow – hopeless love.

STYLISED ROSE

PIETY

Acacia – immortality of the soul.
Almond – divine approval, favour and also hope. (The Virgin Mary is sometimes shown with an almond.)
Bull rush – hope, by the faith of salvation.
Carnation, red – pure love. (Ancient varieties had long yellow stamens which were said to look like nails, so red carnations with these stamens were used to represent the passion and crucifixion of Christ.)
Christmas rose – the nativity.
Clover leaf or trefoil – the Trinity. (St Patrick is said to have used the shamrock's trifoliate leaf to explain the doctrine of the Trinity in the fifth century.)
Columbine – the Holy Spirit. (The flower looks like a group of doves drinking at a fountain, and its name is derived from columba, the Latin for dove. It also represents God's seven great gifts and the works of the Holy Spirit.) Conversely, the columbine also represents folly and anxiety.
Cowslip – divine beauty.
Dandelion – the passion of Christ (because the leaf resembles a thorn).
Glastonbury thorn – the nativity when shown as a single rose with bud and leaves. (Joseph of Aramathea was said to have made a visit to England and to have stuck his staff into the ground at Glastonbury. This apparently took root and grew into a wild rose bush.)

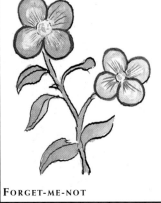

FORGET-ME-NOT

CARNATION

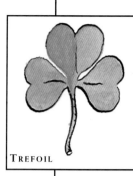

TREFOIL

Grapes – an emblem of Christ, who said: 'I am the true vine. My father is the vine dresser'. Grapes shown with wheat symbolise the Eucharist, the body and blood of Christ.

Holly – the passion of Christ. (The prickly leaves are reminiscent of the crown of thorns and the red berries represent Christ's blood.)

Iris (the sword lily) – sorrow and suffering. (Particularly associated with the Virgin Mary. When Joseph and Mary took the infant Jesus to be presented in the temple, Simeon took the child in his arms and said 'now your servant can depart in peace, for my eyes have seen the salvation that is promised'. He turned to Mary and said 'a sword will pierce your soul, too'. The sufferings of Mary were said to be as swords that pierced her soul).

Lily – purity; the Virgin Mary. (The angel Gabriel is depicted handing a lily to Mary in paintings of the annunciation.)

Lily, Madonna – Easter and purity.

Narcissus – triumph of divine love.

Palm – spiritual victory. (Often shown in association with martyrs.)

Pomegranate – the Church in unity; fertility. (Also the heraldic emblem of the Church of Granada).

Rose, red – emblem of the sorrowful mysteries of the Rosary.

Rose, yellow – emblem of the glorious mysteries of the Rosary.

Rose, white – emblem of the joyful mysteries of the Rosary.

Strawberry – the fruitfulness of God's spirit.

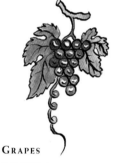

GRAPES

PERSONAL QUALITIES

Alyssum – worth beyond beauty.

Azalea – temperance.

Bachelor's button – celibacy.

Bee orchid – industry.

Bluebell – constancy.

BROOM

Broom – neatness, humility. (A sprig of broom was also the badge of the Plantagenet dynasty of English kings.)

Canterbury bell – constancy.

Carnation, clove – dignity.

Cherry – good works.

Daisy – innocence.

Dock – patience.

Fennel – praiseworthy strength.

Fuchsia, scarlet – taste and gracefulness.

Geranium, red – comforting.

Hyacinth, blue – constancy.

Jasmine, white – amiability.

Iris, rainbow coloured – the bearer of good tidings.

Ivy – eternal life (because it is evergreen). Fidelity (because of the way it clings) and also lasting friendship.

Laurel – victory and triumph.

Larkspur, pink – fickleness.

Lemon blossom – fidelity in love.

Lilac, white – purity, modesty.

Lily of the valley – humility, happiness.

Marshmallow – mildness.

Mullein – good nature.

Oak – faith and endurance.

Olive branch – peace.

Peach – unequalled.

Pink, variegated – refusal.

Poppy – consolation. Head showing all its seeds: fertility in our times, remembrance.

Rose, full open with two buds – secrecy.

Rose, red and white together – together in unity.

Sage – long life and esteem; wisdom.

Salvia, red – energy.

Speedwell – feminine fidelity.

Star of Bethlehem – purity.

Strawberry – righteousness.

Sweet William – gallantry.

Thistle – earthly sorrow and sin.

Valerian, pink – unity.

LAUREL

OLIVE BRANCH

POPPY HEAD

Veronica – fidelity.

Violet – faithfulness; innocence; modesty.

Wallflower – fidelity in misfortune.

Waterlily – purity of heart.

Wheat, a sheaf – riches; thanksgiving.

Wheat, a single straw – agreement broken, quarrel.
Also bountifulness.

DIRECT MESSAGES

Burr – 'you weary me'.

Burdock – 'touch me not'.

Pansy – 'I think of you always'.

Pansy, blue and brown – 'think of me'.

Salvia, blue – 'you are wise'.

Tansy – 'I am your enemy'.

INANIMATE OBJECTS

Hawthorn – bread and cheese (staple foods).

PERSONAL AND NATIONAL EMBLEMS

Iris (sword lily), yellow – the emblem of St Denis,
the patron saint of France and, as the heraldic
fleur-de-lys, the French national emblem.

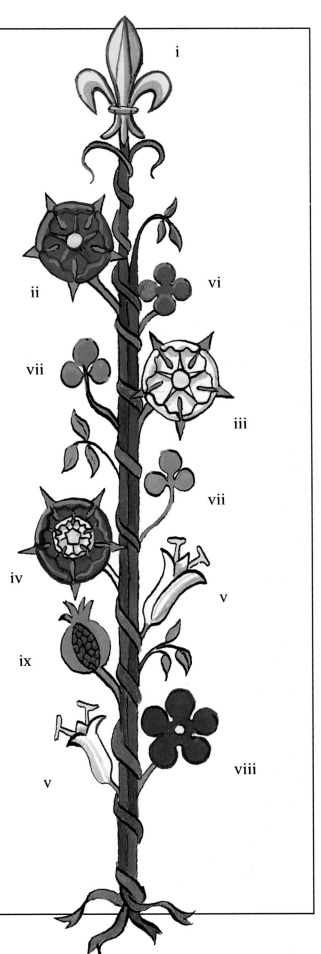

HERALDIC FLOWERS

I FLEUR-DE-LYS

II RED ROSE

III WHITE ROSE

IV TUDOR ROSE'

V LILIES

VI QUATRE FOIL

VII TREFOILS.

VIII CINQUEFOIL

IX POMEGRANATE.

Colours

◆ ◆ ◆

Everyone has their own ideas about colour, and people tend to choose and use those that they like. Colours can make a statement or can harmonise with their surroundings to such an extent that they fade into insignificance.

While you may choose to copy the colour schemes that I have used in the projects in this book, it is important to remember that I have chosen them because they harmonise with other projects, because they introduce a new element, or simply because I like them. Do not be afraid to change the colours that I have chosen if you would rather use different ones. Unless you want to create an accurate copy, you should regard the projects, or other exemplars, as models and guides.

MIXING COLOURS

It is very tempting to buy a selection of colours to save yourself time and trouble. (You will see that I have used a selection of ready-mixed colours in the projects.) If you can, however, try to avoid buying greens, for if you do so your work will always have the same look.

There are only three basic colours – red, yellow and blue – all the others are derived from mixing them. You should attempt to undertake your work using only these three colours, experimenting with mixing them so that you learn to produce all the colours that you need. For example:

<div align="center">

RED AND YELLOW = ORANGE

YELLOW AND BLUE = GREEN

BLUE AND RED = PURPLE

</div>

Try mixing the yellow and blue first, as this gives the most obvious effect. Mix a dish of strong yellow (you do not need a lot). Add two or three brushfuls of clean water so that you produce a modest puddle of colour. Add one dab of blue, mix the colours and then paint a small dab on a clean sheet of white paper. Repeat with a second brushful of blue, mix the colours again and paint a second dab neatly beside the first. Repeat this process over and again. You will thus gradually produce a range of greens, from the original yellow-green through to blue-green. Do the same with the red and yellow to produce a range of oranges and with the red and blue to produce a range of purples.

SHADES

By mixing any colour with black, a darker tone is produced.

TONES

To produce in-between shades, add grey to your chosen colour.

TINTS

To produce lighter shades, add white (but take care if you are using watercolour, for white introduces an opacity to an otherwise clear colour, which may look out of place).

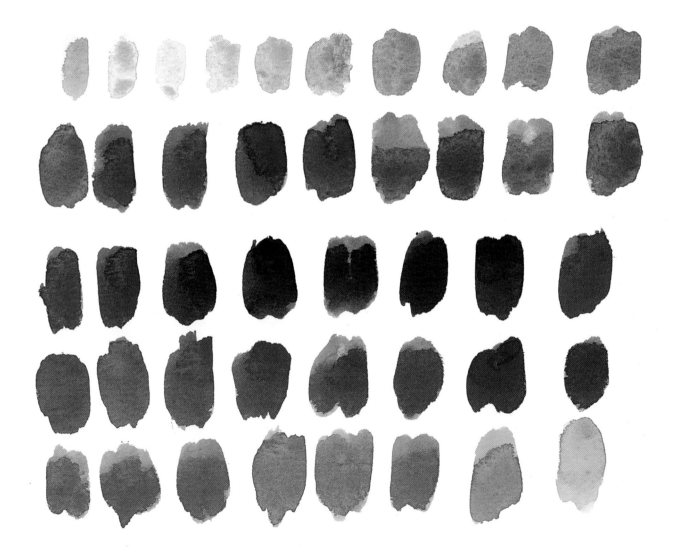

COLOUR CHOICE

In theory, if you draw a colour plan like the colour wheel illustrated, the colours that go together are those opposite each other and those next to each other. Colours also have a heat rating. Reds and oranges are 'hot' and blues and greens are 'cool'.

The subject of your project will have a great bearing on the colour that you use to decorate it. This may seem obvious, but you do need to plan your work so that when it is finished it conveys the right impression. You will soon discover that the most striking effects are produced with the fewest colours, so keep your choice of colours strictly limited. If you look at early medieval works, you will see that they employ the basic primary colours in many small, fragmented areas. When highlighted with burnished gold, a brilliant, jewel-like effect is produced.

COLOUR WHEEL

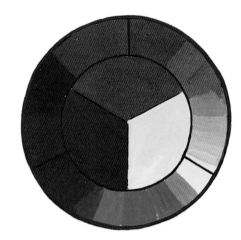

HERALDIC COLOURS

Heradic colours are traditionally described by the names of gemstones and planets, as outlined in the box below.

COLOUR	STONE	PLANET	METAL	SIGN
Gold –	Topaz	Sun	Gold	Leo
Silver –	Pearl	Moon	Silver	Cancer
Red –	Ruby	Mars	Iron	Aries
Blue –	Sapphire	Jupiter	Tin	Taurus
Green –	Emerald	Venus	Copper	Gemini
Purple –	Amethyst	Mercury	Quicksilver	Sagittarius
Black –	Diamond	Saturn	Lead	Capricorn

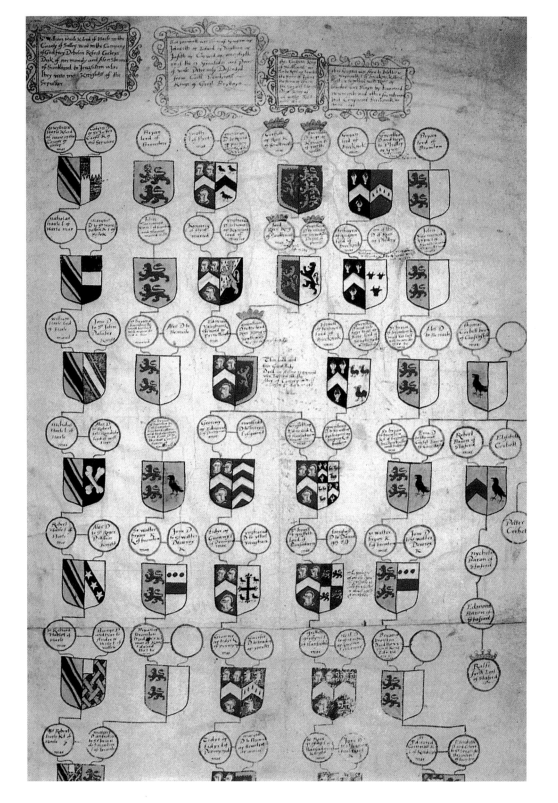

THE SIXTEENTH-CENTURY ARMORIAL FAMILY TREE OF ANNE HALE;
NOTE THE USE OF THE COLOURS YELLOW AND WHITE IN PLACE
OF GOLD AND SILVER.

Heraldry

◆ ◆ ◆

No work dealing with art up to the advent of printing in the fifteenth and sixteenth centuries can fail to take note of heraldry. In an age when the majority of the population was illiterate, easily recognised heraldic devices were used to signify ownership, patronage, possession, authority and corporate identity. Heraldic forms and devices were so important that they appeared on manuscripts and documents, on churches, colleges and buildings, as well as on personal possessions and everyday items. The art form has since developed over the centuries, and although nowadays due regard is paid to historical precedent, it is still evolving and will no doubt continue to do so.

The origins of heraldry lie in the painting of devices on warriors' shields that were intended both to terrify the foe and to invoke the supernatural powers of a protective deity. With the advent of metal weapons, a protective garment of chain mail was adopted, over which was worn a long, loose-fitting surcoat made of stout material. This 'war coat', or 'coat of arms', would be painted with the same device displayed on the shield. (The heraldic coat of arms is more properly called an 'achievement'.) With the advent of metal helmets covering the face, heraldic devices were necessary to identify people in the heat of battle, and so they became personal emblems of identification.
At first people would often use different emblems for different occasions, but later these became both personal and hereditary, when personal emblems, in the form of seals bearing the device displayed on the shield, were used to mark possessions and authenticate documents. An absent lord who needed to communicate with his distant and often illiterate servants would send a messenger wearing a tabard (a garment decorated wth his master's arms) to prove his identity. The messenger would then display the master's seal attached to the message that he was carrying to prove its veracity. When a son inherited his father's estates, he would display the family arms as a sign of his right of possession.

Thus it was that heraldic devices became both hereditary and associated with the titles that were being claimed. Later the achievements became associated with land, and so it became common to see several different devices displayed on one shield as its bearer became more powerful and acquired more land. Each component of such a device is known as a quartering. A shield can have any number of quarterings (sometimes even more than 200).

Sometimes disputes arose over the use of arms, for it was not uncommon for completely unrelated people to adopt the same designs. Eventually the monarch's messengers, the heralds (from whom the word 'heraldry' is derived), adjudicated in disputes and issued new coats of arms to aspirant 'armigers', as one who has the right to bear a coat of arms is called. They also were charged with keeping records and making themselves familiar with the devices of armigerous people. When the monarch

GATEWAY FROM THE SOUTH SIDE OF THE
PRESBYTERY OF THE CATHEDRAL OF NORWICH,
SHOWING HERALDIC DEVICES.

went to war, the heralds were able to recognise members of the opposition by their heraldic devices and thus advise the king of the strength of their forces. After a battle, they identified the slain.

Heraldry is still in use today, for many successful individuals continue to be granted the right to bear arms. Modern heraldic devices are devised to contain elements and designs that both reflect our own time and preserve and uphold the traditions of the last millennia. Corporate bodies, too, can draw on heraldic tradition to proclaim the corporate identity of their institutions.

HERALDIC DESIGN

Because heraldry has its roots in military usage, the few rules that govern it were designed to promote visual clarity on the battlefield. The principle rule concerns colour. The surface of the shield is known as 'the field', and anything that is placed on it 'a charge'. It is vital that the colour of any charge is distinct from that of the field to enable it to be seen clearly. To this end, the colours used in heraldry are split into three groups: 'metals', 'colours' and 'furs' (See Figure 1). Metal must never be placed on on metal or colour on colour. (Furs are not bound by these restrictions.) In practice, gold and silver are not used because of their tendency to

tarnish, and so white and yellow are used instead.

With only this small number of colours available to the designer, it would be impossible to keep arms unique, and so it has become the practice to divide the field into different colours. Each of thes divisions has a name that can be described in two words (see Figures 2 and 3).

CHARGES

Any object that is placed on a field, be it of a whole or divided colour, is known as a charge. A charge is usually chosen because it has some significance for the person who is to bear it. It is impossible to list all of them here, but a few groups need a special mention: the ordinaries, the subordinaries, geometric shapes, crosses, animals and birds

THE ORDINARIES

This group of charges is so commonly used that it is known as 'the ordinaries'. It is thought that the designs were derived from the shield's original strengthening bars. (See Figure 4).

THE SUBORDINARIES

The subordinaries are a group of lesser ordinaries (see Figure 5).

GEOMETRIC SHAPES

A number of geometric shapes are used in heraldry (see Figure 6).

CROSSES

The cross is a very commonly used charge and may appear in over 150 different designs.

ANIMALS AND BIRDS

Animals are very commonly used and appear in a variety of postures (the more common are shown in Figure 7). Similarly, birds often appear in heraldic art and also have a variety of set postures which enable them to be described verbally (see Figure 8). Special terms are reserved for fish and deer, as well as for parts of the human body. The limbs of creatures and humans are shown either 'couped', as if cut off cleanly, or 'erased', as if torn off. (see illustration page 31). The lion and eagle are traditionally considered the most noble of the animals and birds, and the mythical griffin (part lion and part eagle) is said to combine the best characteristics of both and to be the fiercest creature.

SUPPORTERS

Although the shield is the main vehicle for the display of heraldic devices, it is not the only item in a complete heraldic achievement. A pair of supporters – two figures, animal or human – standing on either side of the shield and holding it up are common. (These are derived from the days of knightly tournaments, when the contestants' shields were borne round the arena by two pages).

FIGURE 1

1, 2 THE METALS: GOLD (YELLOW) AND WHITE (SILVER).

3, 4 THE FURS: ERMINE (IN VARIETY), VAIR (IN VARIETY).

5, 6, 7, 8, 9 THE COLOURS: RED, BLUE, PURPLE, GREEN AND BLACK.

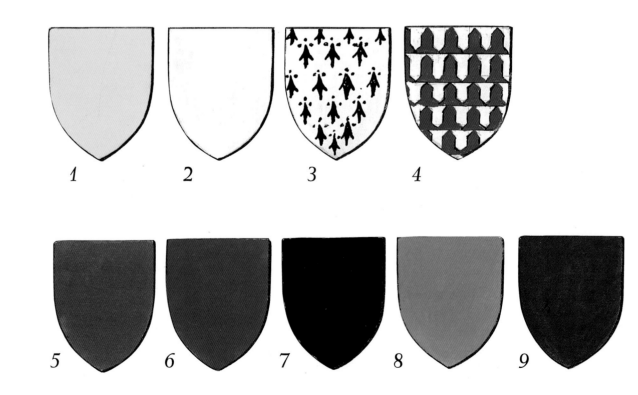

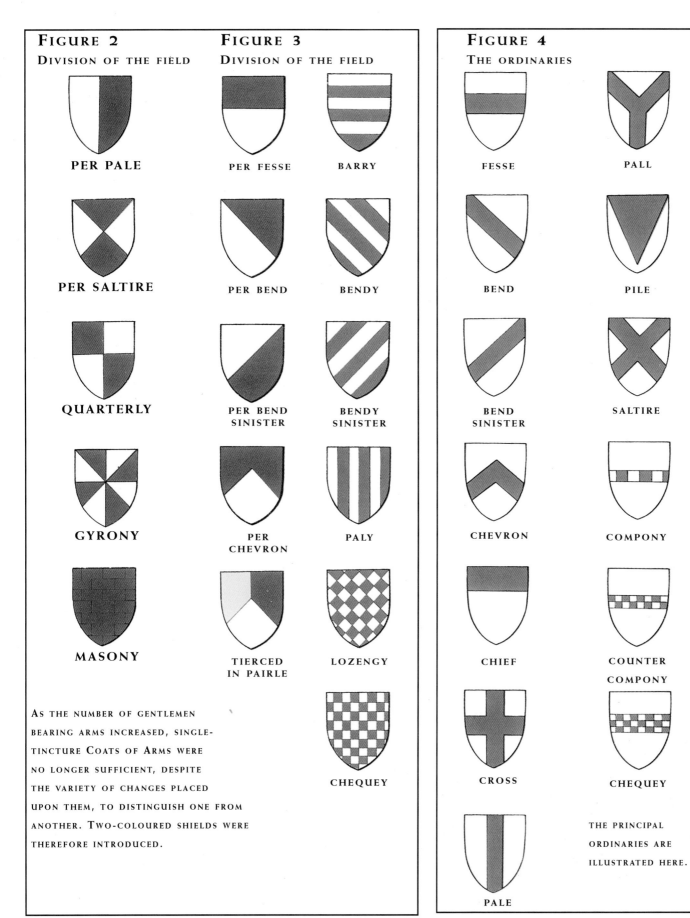

FIGURE 2
DIVISION OF THE FIELD

PER PALE

PER SALTIRE

QUARTERLY

GYRONY

MASONY

FIGURE 3
DIVISION OF THE FIELD

PER FESSE

BARRY

PER BEND

BENDY

PER BEND SINISTER

BENDY SINISTER

PER CHEVRON

PALY

TIERCED IN PAIRLE

LOZENGY

CHEQUEY

AS THE NUMBER OF GENTLEMEN BEARING ARMS INCREASED, SINGLE-TINCTURE COATS OF ARMS WERE NO LONGER SUFFICIENT, DESPITE THE VARIETY OF CHANGES PLACED UPON THEM, TO DISTINGUISH ONE FROM ANOTHER. TWO-COLOURED SHIELDS WERE THEREFORE INTRODUCED.

FIGURE 4
THE ORDINARIES

FESSE

PALL

BEND

PILE

BEND SINISTER

SALTIRE

CHEVRON

COMPONY

CHIEF

COUNTER COMPONY

CROSS

CHEQUEY

PALE

THE PRINCIPAL ORDINARIES ARE ILLUSTRATED HERE.

FIGURE 5
THE SUBORDINARIES

BORDURE

CROSS FIMBRATED

ORLE

CANTON

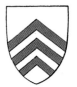

FRET

CROSS QUARTER-PIERCED

THREE CHEVRONELS

FRETTY

TRESSURE

FIGURE 6
GEOMETRIC SHAPES

MOLLET

BILLET

HELMETS AND CRESTS

Helmets appear in different forms, according to the rank of the person. The crest is displayed on top of the helmet. (In medieval times it secured the mantling that hung down behind the helmet to protect the back of the wearer's neck.) The mantling is secured by either a torse or wreath – usually material of two colours twisted into a band that fits round the helmet, coronet or cap of maintenance to keep everything in place. If the bearer is a member of the nobility, their coronet of rank may be displayed below the helmet.

The whole group may be shown standing on a 'compartment', which may display a motto on a riband draped across it.

FIGURE 7
ANIMALS

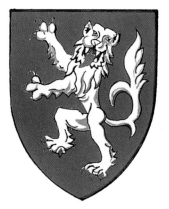

A LION GARDANT HAS ITS FACE TOWARDS THE VIEWER

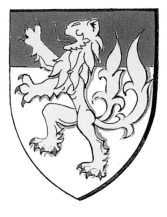

A LION DOUBLE-QUEUED HAS TWO TAILS

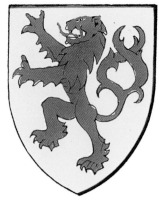

A FORKED TAIL IS CALLED A QUEUE FOURCHY.

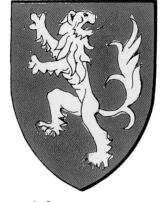

A LION LOOKING BACKWARDS IS CALLED REGARDANT.

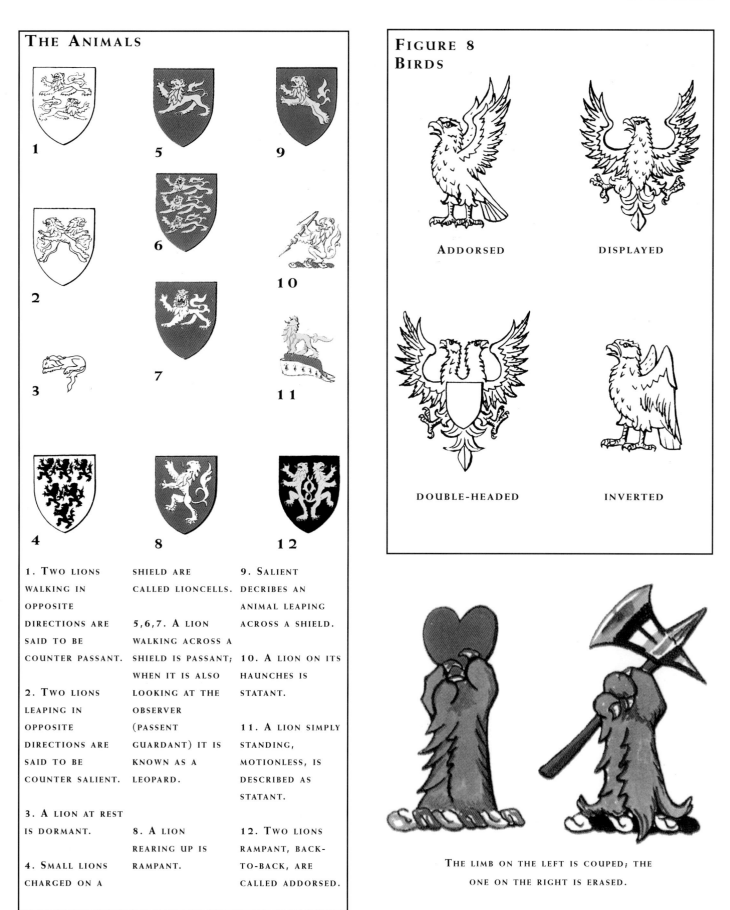

THE ANIMALS

1
5
9

2
6
10

3
7
11

4
8
12

1. TWO LIONS WALKING IN OPPOSITE DIRECTIONS ARE SAID TO BE COUNTER PASSANT.

2. TWO LIONS LEAPING IN OPPOSITE DIRECTIONS ARE SAID TO BE COUNTER SALIENT.

3. A LION AT REST IS DORMANT.

4. SMALL LIONS CHARGED ON A

SHIELD ARE CALLED LIONCELLS.

5,6,7. A LION WALKING ACROSS A SHIELD IS PASSANT; WHEN IT IS ALSO LOOKING AT THE OBSERVER (PASSENT GUARDANT) IT IS KNOWN AS A LEOPARD.

8. A LION REARING UP IS RAMPANT.

9. SALIENT DECRIBES AN ANIMAL LEAPING ACROSS A SHIELD.

10. A LION ON ITS HAUNCHES IS STATANT.

11. A LION SIMPLY STANDING, MOTIONLESS, IS DESCRIBED AS STATANT.

12. TWO LIONS RAMPANT, BACK-TO-BACK, ARE CALLED ADDORSED.

FIGURE 8
BIRDS

ADDORSED

DISPLAYED

DOUBLE-HEADED

INVERTED

THE LIMB ON THE LEFT IS COUPED; THE ONE ON THE RIGHT IS ERASED.

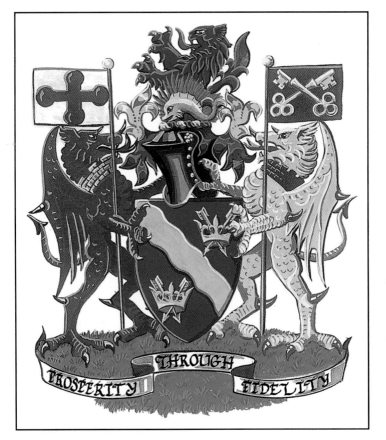

THE ACHIEVEMENT OF
ARMS OF THE BOROUGH
OF BECCLES SHOWING IN
THE FULL ACHIEVEMENT,
TWO SUPPORTERS
STANDING ON A
'COMPARTMENT' OF
GRASS.

INSIGNIA OF OFFICE

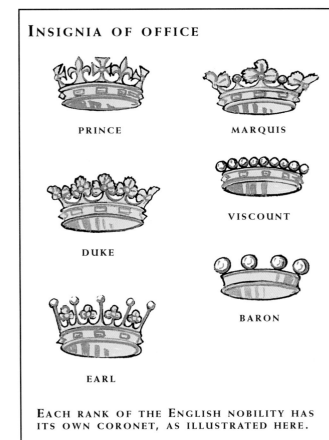

PRINCE

MARQUIS

DUKE

VISCOUNT

EARL

BARON

EACH RANK OF THE ENGLISH NOBILITY HAS
ITS OWN CORONET, AS ILLUSTRATED HERE.

GRIFFIN SUPPORTERS

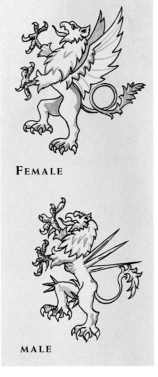

FEMALE

MALE

THE GRIFFIN IS THE KING
OF ALL THE CREATURES.
WHILE THE LION IS THE
KING OF THE BEASTS AND
THE EAGLE IS THE KING OF
THE BIRDS, THE GRIFFIN
BEARS A COMBINATION OF
THE BEST ATTRIBUTES OF
BOTH THESE MAGNIFICENT
CREATURES. THOUGH BOTH
FORMS ARE SHOWN, THE
MALE FORM IS RARE.

Basic Techniques

◆ ◆ ◆

MATERIALS AND EQUIPMENT

You may be surprised at how much equipment you will need to paint your own illuminated letters, but do not rush off to the art shop and buy a basketful of different things, because in most cases you can initially use items that you already have to hand. As time goes by, you will develop your own way of working, using your own preferred selection of tools.

YOUR WORK STATION

It is very important that you make your work station as comfortable as possible. You will inevitably become enthralled with what you are doing and, before you know it, you will have spent several hours on your task. You do not then want to get up from your work with a cricked neck and stiff all over. It is also important that you have all that you need close at hand so that you do not have to keep getting up to select your tools. While this may have the advantage of preventing you from

becoming stiff, it will play havoc with your concentration and patience.

Where you work, depends on both your preferences and your particular situation. I have a small studio with a computer stationed at one end and a glass-engraving desk at the other end of the same bench. My small adjustable drawing board fits exactly under the mantelpiece, so I keep all my equipment there, putting the things that I need for a particular project on a small table nearby. There is a large, full-length window, but I have become used to keeping the curtains shut as I found the extraneous light distracting when I was working at glass-engraving, and so I decided that it was better to work in the dark, with just a small light positioned in front of my face but below eye level. I sit on an old kitchen chair, which is just the right height for me; although it is not very beautiful, it is comfortable, solid and does not wobble about.

LIGHT

Make sure that you have a good light with which to illuminate your work: a long-necked lamp is ideal. Position it so that it neither shines into your eyes nor throws shadows from your hands onto your work, thereby obscuring your view.

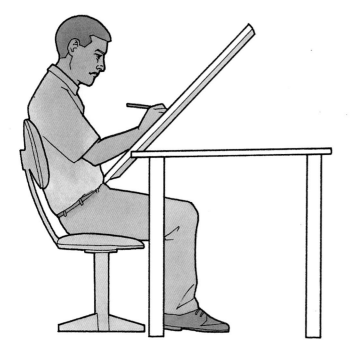

THIS SKETCH SHOWS
THE DRAWING BOARD
POSITIONED IN THE
LAP AND RESTING ON
THE TABLE.

<div style="border:1px solid">

TIPS

MAKING YOUR OWN DRAWING BOARD

THIS SKETCH SHOWS THE DRAWING BOARD POSITIONED AT THE EDGE OF THE TABLE TO PREVENT YOU FROM LEANING YOUR ELBOWS ON IT, SO LEAVING YOUR HAND

FREE TO MOVE. IT ALSO DEMONSTRATES THE POSITIONING AND USE OF THE T-SQUARE AND RIGHT-ANGLED SET SQUARE.

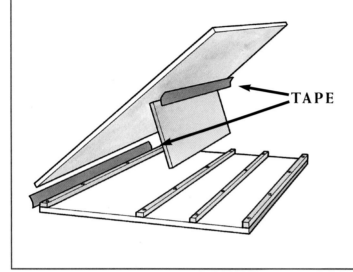

TAPE

</div>

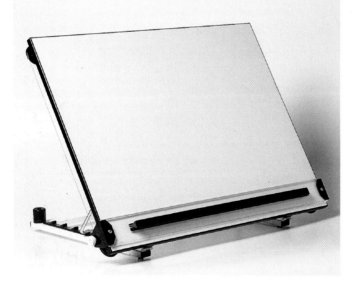

ALTERNATIVELY YOU CAN BUY A READY MADE DRAWING BOARD, WITH A VARYING ANGLE. THESE ARE ATTAINABLE FROM MOST GOOD ART SUPPLY SHOPS.

BASIC EQUIPMENT

If you haven't got an adjustable drawing board, you can easily adapt something suitable to make one. If you have an ordinary drawing board, or a piece of plywood that is thick enough not to bend when you lean on it, you can set it up on a table, propped up on some books or a large tin, or on anything else that you have at hand which suits the purpose. Make sure that the front edge of your board is aligned with the edge of the table to prevent you from resting on your elbows.

You could sit with the front edge of the board resting on your lap, but if you do this make sure that you have everything that you will need ready on a side table so that you do not have to keep putting the board down whenever you want anything. You could easily make a small board to stand on your table, using three pieces of plywood, some small battens and a roll of masking tape (see above). Failing all these things, you could use the back of a big tray.

If you are not used to working on a sloping board, you may find it uncomfortable for a while. At first,

everything seems to fall on the floor, but it is
nevertheless worth persevering because it is not only
much easier to view your work on a sloping board, but
you can also ensure that you are keeping everything
straight and that your vertical lines and strokes are truly
vertical. If you are sitting comfortably and firmly on
your chair, with your weight solidly distributed across
the seat, you will more easily be able to resist the
temptation to lean on your elbows. For if you lean on
your elbows you restrict the freedom of movement of
your arm, hand and wrist, which obviously hampers
your drawing ability.

Make sure that you have a side table on which to put
everything that you will need so that your pens and
pencils are resting on a level surface. Cut two or three
pieces of paper to the size of your drawing board and
tape these on with masking tape to act as a pad. You will
find that all kinds of nibs will work better on this more
yielding surface.

T-SQUARES

If you have not got a proper drawing board with a
parallel rule attached and you are using a board of your
own devising, you can nevertheless set up your work
with the aid of a T-square. If you have not got one of
these, it is really worth buying because it will enable you
to keep your work true, both vertically and horizontally.
They are not that expensive and will always come in
useful for future projects.

A T-square is literally T shaped. The head is short and
thick and, when in use, overhangs the edge of the
drawing board to which it is pressed so that it can slide
up and down. The leg is both longer and thinner, and is,
in fact, a ruler which is attached very carefully at right
angles to the head.

Place the T-square on the board, making sure that it is
pressed firmly against the edge. Slide the top of your
piece of paper under the T-square so that both are lined
up exactly. Next slide your T-square down the page
without moving the paper, and stick down the paper
lightly with some low-tack masking tape. By sliding the
T-square up and down you can now make the parallel
and horizontal lines and marks that you need.

TIP

COMPASSES AND DIVIDERS

Compasses and dividers are essential when marking
out your page. Once you have established the line
size to be used, you can set your compasses or
dividers to that width by measuring your nib size
and can then 'walk' them down the page, marking as
you go. This is a lot faster than marking off
measurements from a ruler with a pencil.
Buy two compasses – the sort made of two parts
and held together at the top with a little nut and
bolt. Take them both to bits and then put them
back together again, but this time positioning the
pencil-holding ends together and points together.
Screw them together tightly so that they can be
altered but do not move easily when in use.
Sharpen two short 2H pencils and put one in each
pencil-holder so that their two points meet. You
have now got both a pair of dividers and a useful
tool for drawing pairs of lines of any width.

RIGHT-ANGLED SET SQUARES

By taking a right-angled set square and sliding it along your T-square, you can make vertical lines and marks wherever you want. This will greatly facilitate any ruling and marking out that you may need to do. No doubt you will initially feel that you need as many hands as an octopus in order to do this, but after a bit of practice you will soon see that it is not as difficult as you first thought.

RULERS

You will need to use a ruler to measure your layout plan. Make sure that you can read the markings on your ruler easily – there is nothing more annoying than having to count along the ruler if the markings have become worn or obscured. You will also find a ruler useful for drawing the occasional straight line.

VELLUM, PAPER AND CARD

When about to embark on a project, the first thing that you will need to consider is what material to use for your work. The answer usually lies in the question 'What is the finished project to be used for?'

Whatever material you use, it needs to have some essential qualities. The surface must be smooth enough to allow the pen nib to glide easily across it without snagging and impeding the smooth execution of the stroke, or, even worse, catching in the surface and causing a splatter of ink to explode in all directions. The surface must also be of sufficient weight to support the work without wrinkling or sagging. If the completed work is to be framed, the material must furthermore be sufficiently strong to remain flat in the frame. If you are making a scroll, on the other hand, it must be limp enough to allow you to roll it up without creasing or cracking it. You want your completed work to look right, and so, while bearing the above considerations in mind, you should chose the material that you both like and feel is appropriate for the task.

VELLUM

Vellum has been used since Roman times and is still available today. Made from specially prepared sheep- or calfskin, it is a very durable material that is typically used for projects that are intended to last. It is also the preferred material for the very finest and most prestigious work.

If you intend to use vellum, choose your skins carefully and, if you need more than one for a project, try to match their colours. Vellum is quite difficult to store. Keep it flat in a dry drawer until you need to use it, but note that if it dries out it will become hard and cracked and if it is too damp it will become mouldy.

Vellum has a smooth side – the outer – and a rough side – the inner. It is not of a uniform thickness, so when you cut out the section that you want to use try to cut a piece that is of the same thickness. When cutting it, use a sharp craft knife and a steel rule to cut against. If you have a rubber cutting-down mat so much the better,

BECAUSE VELLUM IS A NATURAL PRODUCT IT VARIES IN COLOUR AND TEXTURE.

but you could use a piece of wood or hardboard or, for a small piece of work, a spare vinyl floor tile instead. If the finished work is to be framed, remember to leave enough round the edges to fill the frame when you cut your piece out.

POUNCE

First your piece of skin needs to be degreased. Even though it will have been extensively treated, it still has a greasy surface that will repel ink and water-based paint. In order to degrease it, you will need to rub the surface with a prepared powder called pounce. This acts as an abrasive and, as well as removing the grease, raises a fine nap on the skin which makes a key for your inks and paints.

Pounce can be prepared by mixing one part cuttlefish bone, two parts pumice powder and a half-part of gum sandarac. These ingredients can be obtained from a specialist art supplier and should be mixed and ground together in a mortar and pestle. Sprinkle some of the pounce on your vellum and, using a scrap piece of skin, rub it all over the surface until it feels smooth. When you are satisfied, brush off all the powder into a jar to keep for future use (do not forget to put a label on it). Once the skin has been pounced, avoid touching it with your hands: even the cleanest person leaves greasy fingerprints which effectively reapply grease to the surface.

PAPER AND CARD

There is now a large variety of paper available from art shops. There are even papers that have been produced to look like vellum (but unhappily some of their colours are very bright and rather unsuitable for many projects). The paper needs to be smooth and of sufficient weight to bear the drawing; good-quality cartridge paper is about as thin as you should go. You need to remember that decorative treatments are quite heavy and will cause the paper to sag. Water-based inks and paints will also cause light-weight paper to cockle – to form waves and dents.

Your choice of paper or board will depend on the size of your proposed project, and after careful consideration you may well have to settle for using a different material to your first choice, or otherwise modify your ideas.

For a big estate map that I once drew (see below), I needed paper that was 4 feet (1.23m) wide on the roll. I had to buy a whole roll of an Italian paper, Fabriano FA4. It is a heavy, smooth paper, which is nice to work on. It is a little stiff and very absorbent, so a drop of water spilt on it would raise a bump almost instantly. I soaked the paper, using a bowl of water and a shaving brush, and it subsequently accepted washes and other treatments. Luckily, I have since used up most of it, so it was a useful investment. If your work is to be framed, chose some Bristol board, which is both smooth and stiff and will not sag in a frame.

KEEPING YOUR WORK CLEAN

However hard you try, you cannot avoid transferring grease from your hands to the working surface. This will repel ink and watercolour and will give a ragged and unclean look to your work.

It is a good idea always to place a piece of scrap paper underneath your pen hand, which will keep your fingers from making contact with the surface. Another tip is to tape or pin a piece of paper onto your drawing board, underneath the spot where your hand most comfortably rests. You can then place your work under this, leaving just that part protruding on which you are working. This will have the double advantage of protecting the piece from your hands and holding the work in place on the sloping drawing board. You could even go to the extreme of wearing gloves. I once drew a large estate map, 1.23m x 1.52m (4 feet by 5 feet) in size, containing pictures of all the houses on the estate, the village churches, views of the farms, the relevant heraldry and so on. As this was fixed to a very large board that had to be stood against the wall while I worked on the top, and laid on the table while I worked on the bottom, it was

A SELECTION OF PAPERS AND VELLUM. NOTE THE TRANSLUCENT QUALITY OF THE VELLUM.

not practical to position pieces of paper under my hand and so I invested in a pair of white cotton gloves to wear while I was working. It was a revelation to see how soiled they became.

STORING PAPER

Try to store your papers laid flat if you can. It makes life much easier when working on a project, for there is nothing worse than trying to work on a fairly stiff piece that has been rolled up for some time – it is continually curling up and will make you very frustrated.

TRACING PAPER

You will need some tracing paper to trace your chosen designs or other elements that you may wish to incorporate into your own design. You can either buy tracing paper from an art shop or you can use domestic greaseproof paper, which is not quite as transparent but is very much cheaper and, in most cases, serves very well. You can also use tracing-down paper.

Tracing paper is very useful, too, when you are working out a design. Draw your design and then, on a piece of tracing paper, trace over it, making any modifications and alterations that you feel are necessary as you do so. (You may have to do this several times before you are satisfied and it is ready to transfer to your project paper.)

You can also use tracing paper to produce symmetrical designs. Draw or trace one half of the design onto tracing paper. Fold the tracing paper exactly at the point where you want the centre to be and then trace the design from your first drawing. Unfold your paper and you will see two identical halves which are now ready to transfer to your project paper.

TRACING-DOWN PAPER

Tracing-down paper is specially prepared paper, coated with a red powder, that you can buy from art shops. Place the sheet, powder side down, on your project paper, then place your drawing on top of it and draw over it with a fine, sharp pencil. The red powder will

make a clear mark on your project paper, which can be rubbed off with an ordinary rubber after you have inked it in.

Should you find yourself working on red project paper, you can make your own tracing-down paper in any colour you want, to provide a contrast. Take a sheet of greaseproof paper and select a soft pastel in a contrasting colour to the paper. Rub the pastel over the greaseproof paper and then, when you have covered it as well as you can, take a piece of scrap paper and rub it all over the greaseproof paper to smooth out the pastel. You can now use it as you would tracing-down paper.

FROM TRACING TO PROJECT PAPER

Take a 6B pencil and generously go over the back of your drawing on the tracing paper. When you have done this, place the tracing paper the right way up on your project paper and draw over it again, taking care to be accurate. The coating of 6B lead on the back will leave a clear impression on your project paper.

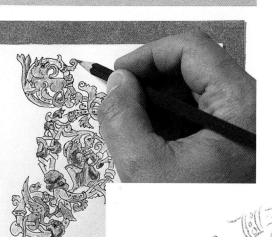

LEFT SHOWS THE USE OF TRACING DOWN PAPER, WHILE BELOW YOU CAN SEE THE IMAGE OBTAINED.

PENS

If you intend to do your drawing in ink, you will need a pen with a fine, pointed steel nib. A mapping pen is ideal. This has a very fine, soft and flexible nib – the harder you press, the wider the line becomes. It is also possible to draw long, swelling lines with it that will give your work character and style.

As well as mapping pens, other pens with thin, pointed nibs that are stiffer and make wider lines can be obtained from art shops.

TECHNICAL-DRAWING PENS

You can buy technical-drawing pens from shops that deal in art and drawing office supplies. As well as offering nibs in a variety of different thicknesses, they have a cartridge for ink which is fed to the paper through a thin tube that serves as the nib. When the cartridge is empty, it can be refilled from a special bottle (supplied with the pen).

When they work well, technical-drawing pens are wonderful instruments that will write for hours. They also have disadvantages, however. This first is that they make a continuous fine line that never varies in weight; this is ideal for technical drawing but lacks the style and elegant touch needed for fine artwork. The other drawback is that if you leave them unused for any length of time the ink in the little tubular nib becomes dry. They are very difficult to unblock and much valuable time can be lost in trying to wash them and get them working again.

CALLIGRAPHY PENS

You will not use calligraphy pens for drawing initials, but as you will need them to transcribe the accompanying text – which is as much a part of your project as the initial – it is important to know something about them.

Their nibs are chisel shaped, which means that they make a thin line when moved sideways and a thick line when drawn downwards. On no account try to push them upwards, for the corners will stick into the paper and cause a disastrous splatter or even tear the paper. It is very important to hold calligraphy pens lightly when using them, so that the whole width of the nib rests on the paper and gives you a clean line of even thickness. You should also remember to maintain the correct pen angle when working across the page so that your thick and thin lines maintain the right proportions.

You can buy nibs for calligraphy pens in a variety of sizes. The size of nib that you will need depends on the size of the lettering that you require. Usually the ideal procedure is to rule two lines within which to contain your lettering that are four or five nib widths apart.

FOUNTAIN PENS

There is a variety of fountain pens made for calligraphy. Some of them write very well, others are awful. They have one drawback: most require ordinary, non-waterproof ink to prevent them clogging up. If text is what your project is all about, this may be perfectly acceptable to you, but if you make any mistakes it is difficult to correct them.

PENS WITH SYNTHETIC NIBS

There are many such pens available for use for both drawing and calligraphy and they can be very good value. They tend to dry up if they are left unused, however, and many do not contain waterproof ink. It is also fatal to use them with watercolour when drawing, as they tend to run. But you could use them for outlining your artwork when it is dry, though they have a tendency to bleed into thick gouache paint.

QUILL PENS

Quills are as yet unsurpassed in terms of the quality of the work that they produce when properly cut and used. If you are right-handed, you should ideally chose the feathers from the left-hand wing of the bird because they curve away from a right-handed person. In practice, however, the quill is typically shortened and the barbs stripped off, so the curvature is of little significance to the user.

TIPS

MAKE YOUR OWN QUILL

THIS ILLUSTRATION SHOWS HOW TO CUT AND TRIM A QUILL ACCORDING TO THE INSTRUCTIONS GIVEN IN THE TEXT.

CUT

STAB

CUT

TRIM

CUT

THIS SHOWS HOW TO FIT AN INK RESERVOIR TO A QUILL PEN. FOLLOW INSTRUCTIONS ON OPPOSITE PAGE.

First take a sharp knife and scrape all around the end of the quill to remove the protective wax coating, then trim off the barbs and shorten the quill. Turn the quill upside down and cut off the tip with a long, diagonal cut, moving downwards and away from yourself. Clean out the pith inside the quill. Now lay the quill down on a hard surface and stab the point that you have made with your cut from the back so that you make a neat split up the centre. If the quill does not split far enough you may have to make the split longer by pushing the end of a paintbrush into the quill and stretching it so that the split increases. Make a second cut so that you shape two shoulders on your nib. Next trim the nib to the right thickness, taking care to keep the slit in the middle.

Now all that remains is to cut the point square – this is the most important cut of all and should be done very carefully. Turn the pen up the other way so that the front is facing upwards, and place only the tip of the nib on a hard surface. With a sharp knife, cut downwards at a long angle so that you leave a square-cut edge, but also one that is very thin where it touches the paper. Quills need periodic recutting to maintain their fine edges.

You can make pens from any hollow-stemmed plants – reeds, nettles, elder, bamboo and so on – in much the same way as shaping a quill. You can also cut notches into them so that they make double lines or produce other effects.

INK

A large variety of ink is available from all art shops. Ideally, you should use waterproof ink. Indian ink is both waterproof and dense: it does not become thin when you are drawing a long stroke and, best of all, it will not run. You can thus use it with watercolours and you can also make corrections.

There are all kinds of coloured inks available, too, which are fun to use. One of their disadvantages, however, is that they tend not to be very dense, so at the point where one stroke crosses another you often get a darker patch of colour which gives the work an uneven look. For coloured work, it is therefore better to use gouache paint. Mix it carefully so that it is thick enough to remain opaque, yet thin enough to run from your pen. As well as being of a much brighter hue than coloured ink, it is denser and remains constant in tone.

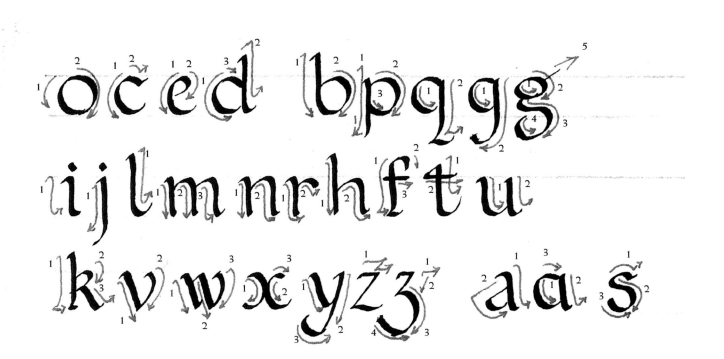

RESERVOIRS

One problem inherent in all pens which need to be dipped is that they very soon run out of ink – in some cases they will only write one letter. This obviously slows you up and breaks your rhythm. If you are using a steel nib, you can buy a little reservoir that clips onto the back of the nib and holds a good supply of ink, thus allowing you to write for some time. Some nib-holders also come with a little tongue that sits behind the nib and serves the same purpose.

If you are using a pen that you have cut yourself, you will need to be a little more enterprising, however. Cut a thin strip of soft tin (of the sort that is used for cigar tins) of the right thickness to go inside the stem of the pen that you have cut. Fold one end to make a hook and push it into the pen. This makes a little tongue that sits behind the nib and forms a very satisfactory reservoir.

PENMANSHIP

Excellence in penmanship is only attained by perseverance and practice. It is a skill that can be mastered, but if you are going to excel in it then you must be determined to do so and practise hard.

That point having been made, however, there are other things that you can do which will greatly assist you. You must be able to concentrate on your work, for example, so leave yourself sufficient time either to complete the piece in one go or at least to write a significant part of it – a paragraph or sentence, perhaps – without interruption. If you stop work in the middle of a passage and then start again later you will clearly be able to see the point at which you stopped: no matter how hard you try, there will be discernible differences in your hand.

POSTURE

The importance of good posture cannot be emphasised enough. Chose a solid chair which is both comfortable and doesn't wobble. Sit upright, so that your hand can rest comfortably on the paper and do not lean on your elbows. If your chair is not high enough, either get another or use a cushion.

SLOPING BOARDS

If you are not using one already, you will find that your work will improve immeasurably if you use a sloping board. When sitting upright in front of such a board, you will be able to see your work more truly and will thus be able to judge more easily whether it is straight. If your chair is of the right height (you may have to experiment with this), only your hand should rest on the board's sloping surface; your elbow should be free to move. You should never sit with your elbow or forearm resting on the board, as this results in a cramped style and restricts your freedom of movement.

At first, you will no doubt find that your paper keeps sliding to the floor whenever you lift your hand. To remedy this problem, sit comfortably in your chair with your feet flat on the floor and your weight firmly distributed over the seat; now take up your pen and place your hand on the board in a writing position. Next put a spare sheet of paper under your hand so that if you were writing you would write just above it. Now take some masking tape and stick the paper to the board at the sides. Slip your project paper under this, with just enough on which to write protruding. This serves three very important functions which will greatly help you when you are writing. Firstly, it stops your paper from falling to the floor. Secondly, and most importantly, it prevents your pristine piece of paper from picking up any grease and dirt from your hands. Thirdly, it ensures that you are always writing in the most comfortable position.

NIBS

Calligraphy pen nibs are shaped like little spades or chisels. It is this shape that gives the form to the letter.

If you have a fountain pen, by all means use it, but note that these pens have an important drawback: they cannot use waterproof ink as it is too thick and blocks their little tubes. Waterproof ink enables you to make corrections, so it is preferable to use a dip pen.

Look at your nib. Chisel end calligraphy nibs have two sharp corners. They present a problem, however, in that if you push the nib up the page one or other of the corners will stick into the paper and make a splatter or blot. When using this type of nib, it is therefore essential to form your letters using only those strokes that are pulled downwards or sideways. Given this requirement, you will immediately appreciate that you will have to learn a completely new method of writing. Do not think of it as writing at this stage: regard it instead as drawing letters.

If you have a dip pen, you may need to 'flame' it before you can use it. It may be that your nib is covered in a protective coating of lacquer to prevent it from rusting which, unless removed, will repel ink and thus prevent the nib from working as it should. To remove the lacquer, pass the nib briefly though a match or lighter flame and the lacquer will burn off with a little puff of smoke. As soon as you see this happening, plunge the nib into some ink to quench it. It should now write perfectly.

To start off with, I recommend that you use a medium- or 2´-sized nib. This will produce much larger letters than you are probably used to, but at this stage you are still learning how to form the letters, so you need to be able to see what you are doing clearly.

LOADING THE PEN WITH INK

These instructions apply only to dip pens; fountain and synthetic-nib pens have their own ink supplies already fitted.

It is very important not to try to write if there is any ink on the front side of the nib (the convex face) as this will cause overinking and blobs. You should load your pen

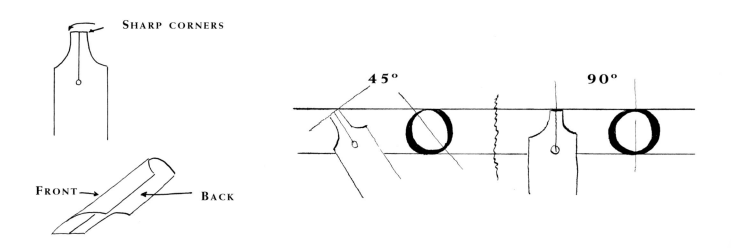

SHARP CORNERS

FRONT → ← **BACK**

45° **90°**

with ink using a brush kept in the bottle. Simply take a brushful and scrape the edge of the brush against the back of the nib; the ink is squeezed into the hollow of the nib, with none collecting on the front. This is also a very useful method when you have mixed up a small amount of gouache paint with which to write, say, just one capital letter and there is insufficient into which to dip the nib. However, I find this method far too slow for writing ordinary text.

When I am writing with my right hand, I hold a piece of tissue paper in my left hand. I dip the nib into the ink and scrape off as much of the ink adhering to the front side as I can on the side of the bottle and then I wipe the front side on my piece of tissue. This procedure removes any ink from the front effectively, leaving me ready to proceed.

One last thing: if you are using waterproof ink, wash out your pen with clean water when you have finished, otherwise it will become clogged up and caked with encrusted ink.

WRITING

Lower your hand onto the paper and let the nib sit on the page at the angle that is most comfortable for you. (Ideally, the nib should touch the paper at an angle of approximately 45°.) Allow the nib to rest lightly on the page, for if you grip too tightly the whole width of the nib could be prevented from resting on the paper, resulting in a ragged, inconsequential line. So, relax and allow the pen to glide smoothly across the page. When you start to use a quill pen, which is much softer than a metal nib, you will have to be even gentler.

Draw the pen down the page so that it makes its thickest line. Now draw it across the page so that it makes its thinnest line. In this way, produce a series of dog-tooth patterns: thick, thin, thick, thin, and so on. This shows you what the pen is capable of doing. As you inscribe the forms for the letters, it is vital that you do not alter the angle of the nib in relation to the writing line. It is this constant angle, and your careful manipulation of it, that produces graceful shapes.

LETTERS

I have drawn the alphabet to show you how to form the letters. Look at the drawings and then carefully follow them. Practise the letters in groups of similar shapes. Start with the 'O' shapes, then the 'L' shapes, then the 'N' and finally the oddments. Leave the 'A' and 'S' shapes until last, as these are quite tricky.

The letter 'O' is the 'mother' of the alphabet. You will notice that this 'O' is thinnest at the top and bottom and widest at the two sides. You can replicate this effect exactly if you place your pen on the paper parallel to the writing line and draw first one curve downwards and then the other. (Note that you should always make an 'O' with two strokes, each starting from the thinnest part at the top and then pulling downwards in a swelled curve so that they meet at the bottom.)

RULING THE PAGE

When ruling your page, remember that you need to allow space for the ascenders and descenders (stalks and tails). There is nothing more unsightly than a mess of ascenders and descenders inextricably entangled with each other. If the body of the text is to be of five nib widths, it is usual to allow four nib widths for ascenders and three for descenders, and so for each line of writing you need to allow four for the ascenders, five for the body text and three for the descenders, making a total of twelve.

Make a mark at every twelfth nib width on a piece of scrap paper or on your backing sheet to use for future reference. Take the measurement with your dividers and mark it down the side of the project page. Now take a line marker made from two compasses and set the two pencils on the two lines that you drew to contain the body of the text. Rule a pair of lines – the bottom one must be ruled on the first of the twelve nib widths that you have marked – until all the lines have been ruled. It is a good idea to pencil a small cross within the lines intended for the body of the text at this stage.

SPACES AND COUNTERS

Spaces are the gaps between the letters and words and counters are the spaces within the letters. These are just as important as the strokes of the letters, for your aim is to produce a page of text that looks even. The text will look too dense if the spaces and counters are too close together and too loose if they are too far apart. The space between the letters should be equal to the size of a lower case 'n'

MAKING CORRECTIONS

Provided that you have used waterproof ink, if you have written a wrong letter you can write the correct letter over the wrong one and then paint out any remaining parts of the wrong one that still show with permanent-white gouache.

If you are using coloured paper, you will have to adjust the colour of the permanent white to match the paper by mixing it with gouache. If you have made a mistake on a drawing, paint out the bits that are wrong; if you intend to colour it afterwards, however, you may have to cover the whole area that is to be that colour with paint so that the white does not show up as a patch in your final colour. If you are working on vellum, you can scrape off the ink with a scalpel or craft knife (but do so with care).

If you are using non-waterproof ink, however, you have a bit of a problem, because the ink will bleed into any pigment that is painted over it. You could try painting over the offending ink with some diluted PVA glue to seal it, and then paint over that with white.

PENCILS AND RUBBERS

You can get by with only one pencil, but a selection will serve you better. Use an HB for normal work and a 2H for drawing and tracing. A 2B is probably the most useful for general-purpose drawing, while a 6B can be used for blackening the back of tracing paper. You must also have a good pencil-sharpener.

It is vital that you have a rubber which you can rely on to do a good, clean job without leaving a greasy smear on the paper. I like a soft, white one and cannot get on with a putty rubber, but if it suits you then by all means use one. The main thing is to keep it clean and to throw it away when it starts to get hard. If it gets very dirty, rub it on a clean piece of paper, which should clean it up. Be very careful if you are using your rubber near gouache paint as it will smudge the paint.

PAINTING TOOLS

Your work will usually be done in watercolour and gouache, so choose your brushes from among the watercolour selection. Watercolour brushes come in a rather daunting variety of sizes and qualities. The sizes that I have found most useful are Nos 6, 2, 1, 00, 000 and 00000. As regards quality, buy the best that you can afford. Sable brushes are the best, being the most springy and retaining a good load of paint. I find camel-hair brushes altogether too soft and 'lazy'. There are some good synthetic brushes available at a very reasonable cost, and I also use these; they work very well and last for some time, as long as I treat them carefully. It is worth getting a larger brush for applying washes if you wish to tint large areas, and also for wetting large pieces of paper so that you can stretch them.

When you have finished using your brush, wash it out carefully with some warm, soapy water and draw it to a point through your fingers. Then stand it upright in a jar or some other receptacle to dry.

Ultimately, you will use whatever receptacle takes your fancy as a water pot. You can buy special pots with wide bases that are not so likely to be knocked over as others or, like me, you can use an old jam jar. Fill it about half full so that you can swish your brush around without the danger of splashing everything in the vicinity.

Remember that a good artist never works with dirty water. If you try to use blue paint with water that is tinted yellow, for example, you will produce a shade of green. If your water is anything other than clean it is not water but weak paint, which will spoil your clean tints.

There are numerous types of palettes that you can buy, but if I want to make up a quantity of gouache to use instead of ink I do so in a white plastic bottle top which gives sufficient depth in which to dip with nib without having to mix up a huge quantity. When I have finished, I leave the mixture to dry; when I need it again I add water and more pigment if necessary.

If I want to mix colours I use a clear-plastic tray, of the type that supermarkets often pack four items of fruit in and which thus has four convenient divisions. Because the tray is very light, I can attach it to my drawing board with a piece of masking tape and thereby keep it close at hand. Being clear, the white paper shows through it and I can easily see the tone of colour that I am mixing.

WATERCOLOURS

Watercolours come either in cake form or in tubes. The colours are clear and allow the paper to glow through, which gives them a translucent effect. If you are going to paint miniatures within your letters you will need some watercolours.

If you buy a set of paints, you will be given a range of colours to work with. If you intend to buy individual colours, however, chose crimson alizarin, light red, yellow ochre, cadmium yellow, ultramarine and cobalt blue, as well as ivory black. You will notice that this selection gives you two different reds, yellows and blues – you should be able to mix all the colours that you will need from these. The black will help you to tone your colours. If you cannot be bothered to mix up your own colours, you should also buy burnt sienna and Vandyke brown. These two browns will both save you some time and help you tone other colours in a less muting way than black.

Do not forget that watercolours are transparent. You do not need white as your paper will generally be white and will shine through your washes, lightening the colours.

GOUACHE

Gouache is essentially a watercolour that is sold in a tube, but it is more thick and opaque than watercolour proper. When it is correctly diluted with water it should give a dense, even colour, allowing no trace of the paper to show through. (If you have difficulties getting the correct consistency, mix a little permanent white with your chosen colour – not enough to change the tone radically, but sufficient to make the density thicker.)

Because gouache colours are opaque, they do not mix as well as ordinary watercolours, which means that you will need to buy some extra colours, especially those in the purple/violet range which are difficult to create by mixing.

Gouache colours are used in the majority of our projects as they have a clear and bright brilliance that cannot be matched by watercolours. If I want a pure colour, I take the paint straight from the top of the tube, mixing in a drop of water to make it creamy enough to use. If I need to mix colours, I squeeze small amounts of the required tones onto a palette and then mix them together on this. (Note: gouache is a little like mustard, however, you nearly always take more than you need and so end up wasting more than you use.)

TEMPERA

Tempera consists of finely dried pigment mixed with egg yolk and a little water to make it usable. It is quite difficult to handle and apply satisfactorily. It is, however, a very durable medium, and was used on ancient manuscripts with the result that they are as luminous and brilliant today as when they were first created.

GOLD

Specks and larger areas of burnished gold on the page give little flashes of light that illuminate the work and give it a touch of exotic luxury.

POWDERED GOLD

When powdered gold is applied to the work, it adds a rich glow to the design that highlights the colours – particularly the lighter ones – with a mellow lustre. When dry, powdered gold has a gritty appearance, but because the particles are very small the little glints of light that they give off are subtle. If this gives the desired effect all well and good, but by carefully burnishing the gold it will appear smoother and not so dull nor as sparkly.

Powdered gold can be purchased in both liquid and paste gouache forms and is very easy to apply with a small brush. You can also buy it made up as either poster paint or ink. Traditionally, you could buy loose powdered gold, which was mixed with a little distilled water and gum arabic. These ingredients can still be purchased from art shops today if you want to work in the traditional way. It is also possible to buy powdered gold (shell gold) that has been prepared in little cakes which can be used like cakes of watercolour.

However it has been prepared, it is very important to keep stirring the medium in order to keep the gold in suspension. Do not dip your brush too deeply into the mixture, or it will simply clog up. Paint with short, almost dabbing, strokes and take care to cover the work evenly, unless it is your intention to allow the background colour to show through. (This can be a very effective treatment which adds considerable richness to the work, so it is worth experimenting with it.)

Powdered gold is useful for small details, as it is easier to apply than gold leaf. It is also very useful for painting a diaper (a decorative, brocade-like pattern painted over a base colour which breaks up the latter and adds greater richness).

When washing your brushes, do so in a small pot with only a little water, to prevent wasting the gold and literally pouring it down the drain. As the gold sinks to the bottom, the water can be poured off every so often.

You will eventually accumulate a usable amount of gold that would otherwise have been lost.

GOLD LEAF

Gold leaf gives a flashing, brilliant effect. Considerable skill and a lot of practice is required to lay it effectively – indeed, it is much easier to describe than to do. Perseverance and patience are the watchwords.

Gold leaf is sold in little books or in loose-leaved packets. It comes in two forms: transfer gold and gold leaf proper. Transfer gold looks like a coating of finely powdered gold mounted on a tissue backing sheet. Gold leaf is a leaf of gold that has been rolled so thinly that it cannot sustain its own weight and therefore has to be mounted on a sheet of tissue paper. It is extremely fragile and will collapse very readily. It also tends to stick to itself, so you must take great care not to let the sheets of gold leaf fold in on themselves.

When applying it to the work, the gold leaf can either be laid flat on the paper or else the form to be gilded can be raised. (It is these raised forms that reflect the light to provide the flashing appearance of fire when they have been properly burnished.) Gold leaf will only stick to your work with the help of adhesive.

LAYING FLAT GOLD LEAF

First paint the area to be gilded with a suitable sizing substance. (Traditionally, this was made with gum-ammoniac crystals dissolved in a little hot water; PVA glue, diluted with some water, will do just as well.) Paint two coats of sizing, allowing the first coat to dry well, since it soaks into the paper. After about half an hour, take the sheet with the gold leaf on it and lay it on the paper, gold side down. Carefully and thoroughly rub and press over

the area. The gold will stick to the sizing and come off the backing paper. Ideally you should use a burnisher to do the rubbing. Its versatile shape allows you either to rub gently, using the broad side, or delicately, using the tip.

If you are not satisfied with the result, lay another coat of gold directly onto the first – the gold will stick to the gold on the page. Now put away your sheet of gold carefully and take up either a piece of greaseproof paper or some tracing paper, and lay it over the gilded image. With the burnisher, gently burnish the gold through the covering paper, taking particular care with the edges. Continue until you are satisfied with the level of brilliance.

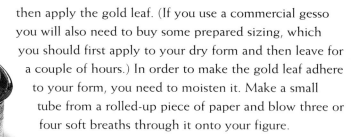

LAYING GOLD ON A RAISED FIGURE

When it has been carefully gilded and thoroughly burnished, a raised capital letter attracts and reflects the light in such a way that it makes the page appear to be alight.

The item must first be carefully drawn in pencil. The body of the form must now be built up with the application of a material to give it weight and shape. This is usually done by painting on two or three coats of gesso.

Gesso is a thick, cream-like substance which, when dry, leaves a raised surface on the page; a second or third coat will raise the surface even higher. Gesso is quite tricky to use. It needs to be of a sufficiently thick consistency to form a raised body of material when dry, but it also has to be runny enough to flow off the brush or nib when it is being applied. Unfortunately, these requirements are not compatible, so it is better to opt for a thin consistency in order to apply it, and then add a second coat.

When you are laying it on, ensure that there are no bubbles, for when it is dry these will look like little craters. (If you make any such bubbles while applying the gesso, prick them with a pin.) When it is dry, scrape it carefully to remove any unevenness. When you are satisfied that your raised form is as good as you can make it and it has dried out properly, you can

then apply the gold leaf. (If you use a commercial gesso you will also need to buy some prepared sizing, which you should first apply to your dry form and then leave for a couple of hours.) In order to make the gold leaf adhere to your form, you need to moisten it. Make a small tube from a rolled-up piece of paper and blow three or four soft breaths through it onto your figure.

If your gold leaf is in book form, carefully cut off a piece of gold and backing paper of the right size; use a pair of tweezers or a small paintbrush to manipulate the cut fragment into place. If it is in loose-leaf form, take the loose page and lay it over your form with the utmost care, allowing as little waste as possible.

With the burnisher, gently rub over the backing paper. Continue until all the gold has become separated from the backing paper and has adhered to the form. Remove the backing paper and examine the result – it may be that another coat of gold is needed. If only a small area of the form is still wanting, use some of the pieces of gold that may still be adhering to the backing paper. When you are satisfied that you have covered all the form, trim it with a craft knife if necessary.

PROJECTS

The projects presented in this book have been chosen to give an overview of the development of the art of illustrated initials, from the time when simple pen-drawn decorations were used up to the time when they were superseded by the advent of printing and the concurrent use of reusable wooden printing blocks for forming letters. I recomend that you work through them, gradually building up your skills.

The skills required for these projects will both tax your patience and satisfy your creative urges, demanding as they do a wide range of required talents. You will need to develop your abilities of both penmanship and draughtsmanship. You will have to extend your ability to be meticulous and consider fine detail. You will need to develop your skills as a colourist and miniature painter. You will be able to put all these skills together to extend your abilities as a designer when you start to use what you have learnt to adapt some of these marvellous pieces of work for your own use.

Projects

• • •

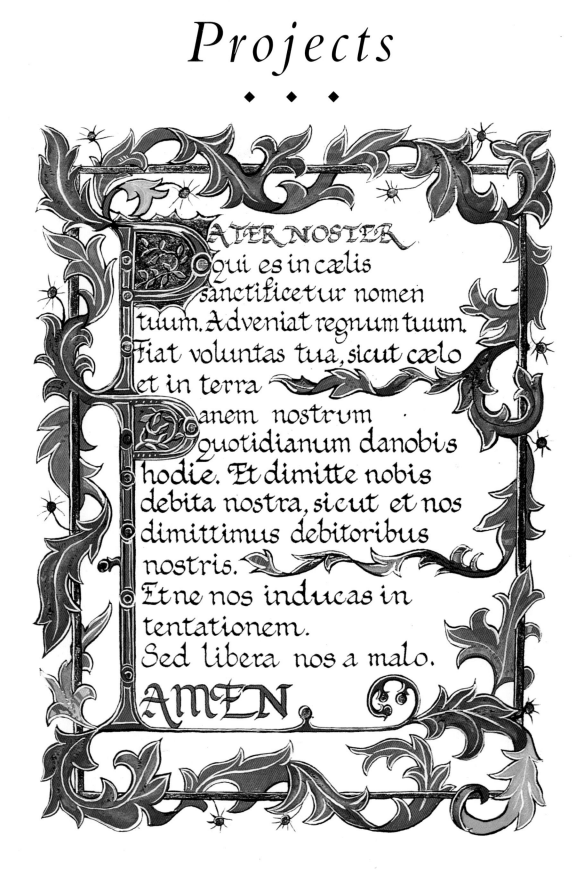

PATER NOSTER
qui es in cælis
sanctificetur nomen
tuum. Adveniat regnum tuum.
Fiat voluntas tua, sicut cælo
et in terra

panem nostrum
quotidianum danobis
hodie. Et dimitte nobis
debita nostra, sicut et nos
dimittimus debitoribus
nostris.
Et ne nos inducas in
tentationem.
Sed libera nos a malo.

AMEN.

Roman Capitals

◆ ◆ ◆

The Roman letters AMDG stand for the Latin words *ad majorem dei gloriam*: 'to the greater glory of God'. I have put them at the beginning of the projects to remind us that our study of illuminated letters is more than simply the pursuit of an artistic whim, and that if we can see it in a more spiritual light we will find the patience to persevere when things get difficult. They also remind us that the basis of the script that we use today is founded upon the Roman capital letters that were carved in stone two millennia ago.

The transcription of these Roman letters makes a very useful first exercise. It will allow you to practise using some of your equipment on an easy project that has a good chance of success. Completing the project will boost your confidence.

YOU WILL NEED

❖ Paper

❖ Masking tape

❖ T-square

❖ Right-angled set square

❖ Sharp 2H pencil

❖ 6B pencil

❖ Rubber

❖ Masking fluid

❖ Nos 1, 6 and 0000 brushes

❖ Palette

❖ Gouache paint: yellow ochre, permanent white, red ochre

❖ 4 drawing pins (optional)

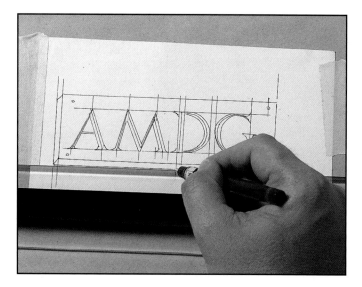

1 Place your paper squarely on the drawing board using a T-square or parallel motion. Lightly tape it down.

2 Draw in the horizontal lines at the top and bottom of the rectangle that will contain the letters and mark the positions of the top and bottom of the letters. (If using a T-square make sure that the head remains in contact with the edge of the board or your lines will be neither parallel nor straight.)

3 Keep a diagram of Roman capital letters to hand. Note the different proportions of the various letters, but use them as a guide rather than an exact measurement.

4 Slide the T-square down the paper so that your drawing area is a little above it. Take up the right-angled set square and rest it on the T-square. By sliding it back and forth you can draw all the vertical lines that you need to complete the rectangle and the position of the letters. (Note that it is easier to mark the middle of the letters.)

5 Untape the paper. You should work on a flat surface from now on.

6 Lightly draw the rest of the letters, taking care to define the thick and thin strokes. If you get it wrong, make your alterations with a rubber, but note that if you have drawn thick, bold lines by pressing down hard you will not be able to do so. Draw the curves of the 'D' and the 'G' freehand, remembering that they should fit into an 'O' shape.

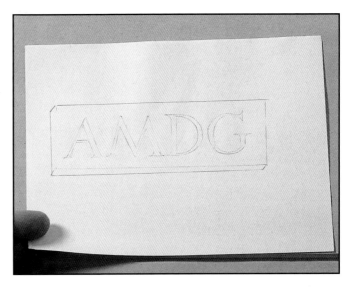

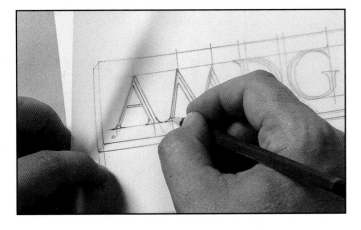

7 Carefully trace the design from the original using a 2H pencil.

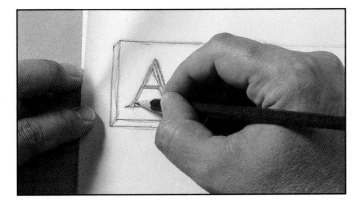

8 Turn over the tracing paper and go over the back of the design with a 6B pencil. Now turn it up the right way.

9 Place tracing paper on your final working paper (shaded side down). Tape down, and copy over your drawing – making sure the tracing paper does not move

10 With the No 1 brush, carefully paint masking fluid onto the letters. It is important that you cover the letters but get no masking fluid on any other part of the paper.

11 Mix a little yellow ochre with enough water to make a milky consistency and paint all over the rectangle with the No 6 brush to make a good, even wash.

12 When the wash is dry, carefully rub off the masking fluid with a rubber.

13 The letters should appear to be cut into stone; these 'cuts' have a dark and a light side. With a pencil, lightly draw the central line of the 'cuts' in the middle of each of the limbs of the letters. Mix a little permanent-white gouache with some of the previously prepared ochre wash and paint the light side of the letters and the end of the slab, using the No 1 brush.

14 Mix a little red-ochre gouache with the wash and paint the dark side of the letters and the bottom of the slab.

15 Take up a little clean water with a No 0000 brush and drop it into the mouth of a tube of permanent white to make the paint creamy enough to paint a highlight onto the exposed edges of your letters and the part of the slab facing the light. You only need to make the lightest indication of a line.

16 When it is dry and you are satisfied with it, pin your work to the wall as a reminder in the future that your hard work can have successful results!

Seventh Century Fish

❖ ❖ ❖

The two fish depicted in this project are from a seventh-century Italian gospel. Fishes are very adaptable creatures to use in letter forms, as they can be straight or curved.

1 Trace the design from the original using a 2H pencil. Turn over the tracing paper and go over the back of the design with a 6B pencil. Now turn it up the right way.

2 Remove the tracing paper and quickly trace the design again onto a piece of spare paper. Colour the design on the spare piece of paper with crayons to test that you are satisfied with the colour scheme that you intend to use. (You may feel that this step is unnecessary and be quite happy with the colours as they are. However it is worth doing, because as well as testing the colours for this particular project, you can keep the crayoned roughs for reference and as source material for future projects. Note: I may not specify this step in future projects.)

TIP

OUTLINING

Outlining requires practice. However, it is worth mastering the technique because it draws everything together, tidies up the loose edges and adds a crispness to the work. Paint straight from the tube, adding water to the mouth until the paint is the consistency of thin cream. Use the smallest brush that you have. Hold quite close to the tip so that it is almost vertical when you use it. Steadily stroke your way round the outlines, overlapping each stroke as you go. You need to paint the thinnest line that you can manage and keep constant. Do not worry if you end up with a slight irregularity in width, but try to avoid painting an overly heavy line as this spoils the whole effect. You can correct or tidy up the odd wobble or stray whisker on the outside with permanent white.

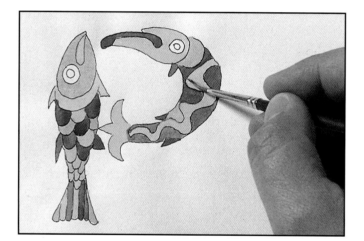

5 Paint the red, yellow and green areas using a No 2 brush and flame red, brilliant yellow and a mixture of ultramarine and yellow. Take the colour directly from the tube, introducing just enough water to make the paint a thin, cream-like consistency. Take care not to paint outside the segments of colour so that the hues are kept clean and the striking effect of the pattern is not diluted.

6 Outline the design with madder carmine and a No 0000 brush (see tip).

3 Tape down the tracing paper. Draw over the design again with a sharp 2H pencil. An impression of the design will be left on your paper from the 6B lead on the back.

4 Mix a little ultramarine and crimson lake, well diluted with water, to make a violet colour and paint these areas. Leave the white of the eye unpainted. Fill in the black of the eye with lamp black or a pen.

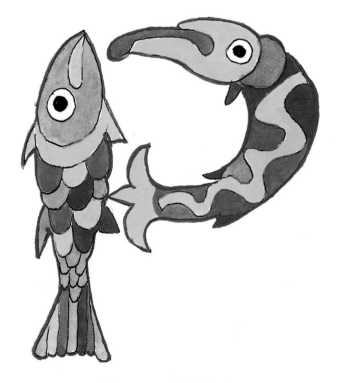

Ninth Century M

✦ ✦ ✦

This handsome 'M' has been copied from a ninth-century gospel. It is a good project to help get you started because it requires you to be neat and exact, so that all the lines which make up its shape are properly parallel to each other and all the blocks are straight. You should do your best to paint and finish it without the aid of a ruler. In this way you will preserve the essential correctness of the design but retain the individuality of hand-done work, which gives freshness and interest.

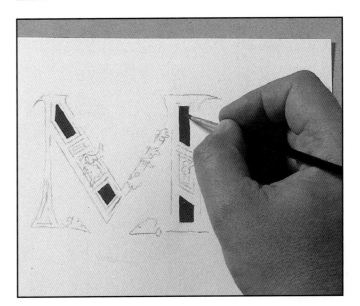

> **YOU WILL NEED**
>
> ❖ Tracing paper
> ❖ Project paper
> ❖ 2H and 6B pencils
> ❖ Gouache paints: yellow ochre, flame red, ultramarine, permanent green (light), madder carmine, crimson lake
> ❖ Crayons in the same colours as the gouache paints (above)
> ❖ Nos 2 and 0000 brushes

1 Trace the outline with a 2H pencil and go over the back with a 6B pencil.

2 Trace the design onto a piece of rough paper and colour it with crayon to test the colour scheme.

3 Trace the drawing onto your project page, checking the image against the original and making corrections as necessary.

4 Paint the red, blue and green areas straight from the tube, using flame red, ultramarine and permanent green (light) and a No 2 brush. Now mix a lavender colour from a watery solution of ultramarine and crimson lake and paint the appropriate areas.

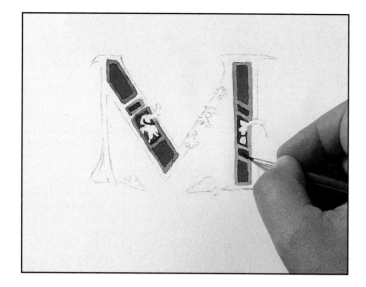

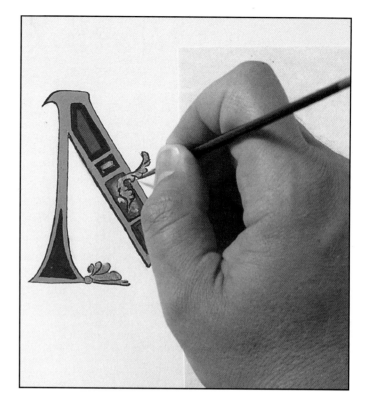

5 Mix a little yellow ochre with some water to make a creamy consistency and then paint the yellow areas, making sure that you preserve the integrity of the straight and parallel lines.

6 Mix some madder carmine with a little water to make a thin, creamy consistency and, with the greatest possible care and using a No 0000 brush, outline the design with a slim, slender line.

7 You may now need to correct the outline from within, using the colour that it covers; use permanent white on the outside.

Eleventh Century Spanish A

❖ ❖ ❖

These two fish form an elegantly simple letter 'A', and were taken from a copy of an eleventh-century Spanish Bible. They offer a good opportunity for you to practise your outlining.

As the project is quite short and the design uncluttered you will be able to work on your outlining without having extra visual distraction. With the longer projects that come later on in the book, where maintaining a crisp outline is so important, it is better to leave this task until you are fresh. However this design will not take long to complete, so you can complete it in one go. Furthermore, the colour scheme is bright and clear, so you will easily be able to see and correct your outline.

1 Trace the fishes with a 2H pencil. If you want them both to be identical and symmetrical, trace only one on one side of your tracing paper. Fold the tracing paper in half, at the point where the middle would have been had you traced the pair. With the first fish on the underside, trace over the outline of the second fish on the top side. You should now find two identical fishes nose to nose when you open up the paper. (This is a very useful method if you have to draw anything that has two symmetrical elements, such as swags, cartouches, shields, hearts and so on.)

YOU WILL NEED

❖ Tracing paper

❖ Project paper

❖ 2H and 6B pencils

❖ Nos 2 and 0000 brushes

❖ Gouache paints: yellow ochre, madder carmine

❖ Indian ink

❖ Mapping pen

2 Pencil over the back of your first tracing with a 6B pencil. Place the tracing on your project paper and trace down the design.

3 Take some yellow ochre mixed with enough water to make a weak wash and quickly but carefully paint over each fish with a No 2 brush, leaving out the eyes.

4 While the wash is still wet, paint the fishes all over, using a No 2 brush and taking paint directly from the tube of yellow gouache. The damp surface will create an opaque, all-covering coat that is both dense and even.

5 Mix some madder carmine with water until its consistency is like soft cream. (It needs to be runny enough to flow onto the work easily without picking up the yellow ochre underneath. It also needs to be thick and opaque enough to cover both the yellow pigment and the white of the paper.) Outline the images using a No 0000 brush. If necessary, tidy up the outline on the inside with yellow ochre and on the outside with permanent white. Paint the pupil of the eye with madder carmine.

6 With a mapping pen and Indian ink, draw in the fish scales. (Take care not to have too much ink on the pen or it will bleed into the paint. Also try to make sure that you do not press too hard when you are drawing on the paint, otherwise you will cut into the surface with the sharp nib.) Finally, draw the fountain.

Twelfth Century German S

· · ·

This elegant 'S' comes from a twelfth-century German Bible, and is a test of your drawing skills as much as your colouring ability. The creatures in this letter put one in mind of two puppies disputing over a leash. Whether they had any symbolic significance, we no longer know.

YOU WILL NEED

❖ Tracing paper

❖ Project paper

❖ 2H and 6B pencils

❖ Nos 1, 2, 0000, 00 brushes

❖ Gouache paints: yellow ochre, red ochre, permanent white, alizarin crimson, ultramarine, permanent green

1 Trace the design using a 2H pencil. Go over the back with a 6B pencil and then trace it down onto your project paper.

2 Paint the two creatures' heads as follows. (Note that they are painted with yellow ochre on one side and red ochre on the other.) First paint both heads with water, using a No 1 brush, to dampen them. Paint a little yellow ochre, diluted with water, on the top side and a little diluted red ochre on the bottom side. With a wet No 1 brush, blend the two together, so that the dark hue – the red – is on the bottom and the light – the yellow – is on the top and they gradually blend into each other.

3 Join the two heads together with red ochre, carefully painting round the area to be occupied by the blue scales.

4 Mix some ultramarine and permanent white to make a bright pale blue and paint the scales.

5 Change your water and mix it with some permanent white to the consistency of thin cream. Use this to outline the blue scales and to paint the white dot in each.

6 Use alizarin crimson and yellow ochre to paint the leash.

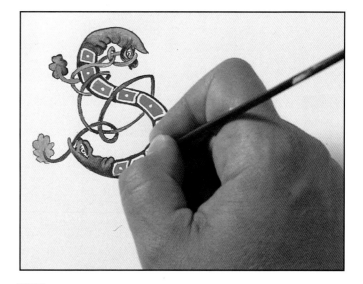

7 Paint the two leaves, one with yellow ochre and the other with permanent green. If you wish to draw out some highlights where the veins go, do so with a squeezed-out brush, but make sure that you do it quickly.

8 Outline the image in red ochre.

TIPS

LIFTING OFF COLOUR

If the creatures appear to be too dark after step 2, and also so that you can work some highlights into the folds of the necks, wet the painting with clean water. Squeeze out your brush between your fingers and then, with the squeezed-out brush, paint over the area where you wish the lightening of tone or highlight to be. Only use one stroke: if you use another you will simply replace the paint that you have just removed. If you still wish to remove more paint, clean the brush, squeeze it out again and only then make a second pass. If you want to remove still more, wet the brush again and repeat the process. You need to be quick when doing this as the colour soon soaks into the paper and then cannot be removed. This lifting-off technique is very useful and has many applications, especially when painting around objects or where you wish to indicate light shining on an object. It can also come to your rescue when you find yourself with a wash that is about to swamp everything, or when two wet

areas of different colours are bleeding into each other. In the latter instance you need to be very quick indeed in order to reverse a potential disaster.

CLEAN WATER

Whenever you want to use a lighter colour, always change your water, especially when you intend to use white. Even the slightest colouring in your water will dull your white, while a touch of blue will turn your yellows green.

Eleventh Century Dutch R

❖ ❖ ❖

This eleventh-century capital 'R', from the Chronicles of William of Jumieges, appears alive with writhing animation. It represents a slightly more ambitious project, building on the drawing skills that you practised in the last project. Study the image carefully before trying to draw it so that you have worked out exactly what is happening.

TRACING FROM A BOOK

If possible, do not trace directly from a book or other type of document. Photocopy the image and trace over the photocopy instead. If you are not permitted to photocopy the book or document, either because you would thereby be infringing copyright regulations or because to do so would stress the book's binding or damage the document, draw the image freehand and then make a tracing from that.

DRAWING YOUR OWN COPY

When you first try to draw a copy of something, you may find it quite difficult. The following tip may help. Draw the image at one end of a piece of tracing paper. Fold the paper over and compare it with the original. Trace off the parts which are good, but alter the elements which were not so good. Fold the tracing paper over your second attempt, as before, and repeat the process. (You may have to do this four or five times.) You may end up with one or two sheets of tracing paper that are folded up like a concertina, but on the top copy you will have a drawing that is as close to the original as you can make it.

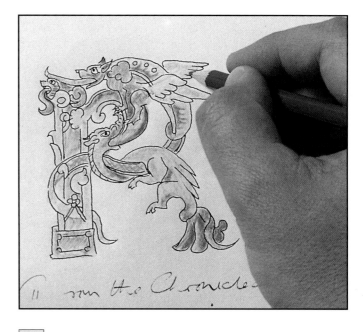

YOU WILL NEED
❖ Tracing paper
❖ Project paper
❖ 2H and 6B pencils
❖ Gouache paints: ultramarine, permanent white, brilliant yellow, flame red, red ochre, Prussian blue, black, permanent green, gold, burnt sienna
❖ Nos 1 and 0000 brushes
❖ A burnisher

1 Trace the image. (I found it quicker to scribble all over the back rather than draw over it with a 6B pencil.) Transfer to your final paper.

2 Mix some ultramarine and permanent white and paint the pale-blue areas.

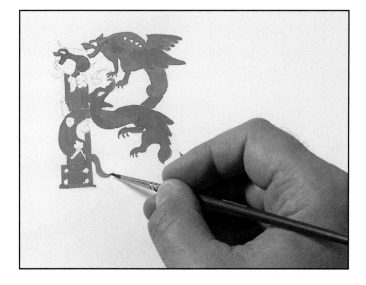

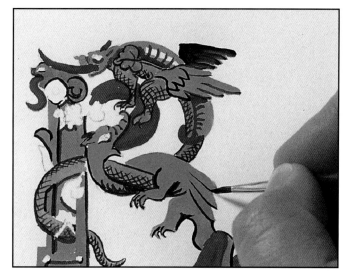

3 Mix some brilliant yellow into your ultramarine and permanent-white mixture to paint the green colours on the frog and the dragon.

5 Paint the shadows on the tongues and tail with red ochre.

6 Paint the shadows on the blue areas with Prussian blue (or ultramarine and black).

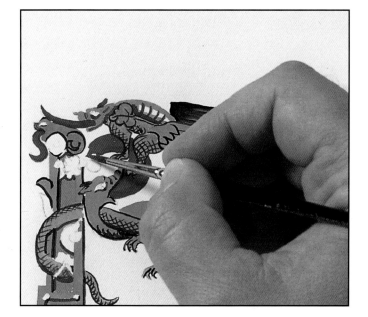

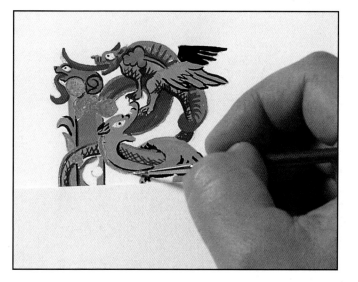

4 Change your water and mix some flame red and permanent white to make the pink for the top dragon and the main stem.

7 Paint the shadows on the green areas with permanent green.

8 Paint the gold detailing with gold gouache. (If you want to give it a slightly smoother and more shiny appearance, you can burnish it with a burnisher. If you do not like the effect, apply another coat of gold paint, which you could reburnish if you wanted to. Experiment and see how you get on.)

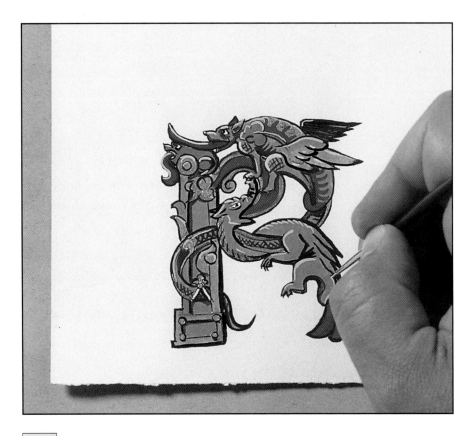

 9 Mix some burnt sienna and black to make a very dark brown and add a little water to give it a consistency like thin cream. With a No 0000 brush, outline the image.

10 Draw in the highlights with permanent white.

Eleventh Century English Q

◆ ◆ ◆

This capital 'Q' is taken from an eleventh-century manuscript of the Winchester school. The skilful juxtaposition of primary colours, together with the small touches of gold, give this capital letter a stunning, jewel-like brilliance.

You will need

- ❖ Tracing paper
- ❖ Project paper
- ❖ 2H and 6B pencils
- ❖ Gouache paints: ultramarine, flame red, brilliant yellow, permanent white, burnt sienna, black, cadmium primrose yellow
- ❖ Nos 0, 1 and 0000 brushes
- ❖ PVA gilding medium
- ❖ Transfer gold
- ❖ A paper tube
- ❖ A burnisher

TIP

TRACING

Take care that you do not move your tracing paper while you are working. It is worth sticking the tracing paper down with low-tack masking tape so that it cannot move.

1 Trace the design. (Take care, because the original is not symmetrical.) Trace the image down onto your project page.

2 Apply the PVA gilding medium to the parts that will receive the gold. Use a No 0 brush to apply the sizing. Resist the temptation to apply a thick drop because when it dries it will shrink and wrinkle. First apply one thin coat and then allow it to dry and sink into the paper. When it is dry, build up the letter form with as many additional thin coats as you need to create the right thickness, allowing each to dry before applying the next.

MIXING PAINT

Make sure that you mix enough paint for the project, if you subsequently find that you have not got enough it is very difficult to mix more that matches your original shade exactly. If you find that you have to use a shade which you will have to mix yourself, it is often worth buying a tube of the equivalent colour. This will both save you time and ensure that you have the right shade to hand.

4 Burnish the gold through the backing paper or a piece of tracing paper and then burnish directly onto the gold.

3 Apply the transfer gold. Before it will stick to the PVA gilding medium the glue in the medium needs to be resoftened. To do this, roll up a little tube of paper to about the size of a cigarette and breathe onto the medium gently. Lay your transfer gold onto the medium, backing paper upwards, and rub it gently with the pointed end of the burnisher. The gold will stick to the letter form and come off the backing paper. Apply another coat directly on top of the first, and then a third. (Note that gold will stick to gouache paint if it has been moistened by a warm breath, so do the writing first, then the gilding and finally the painting.)

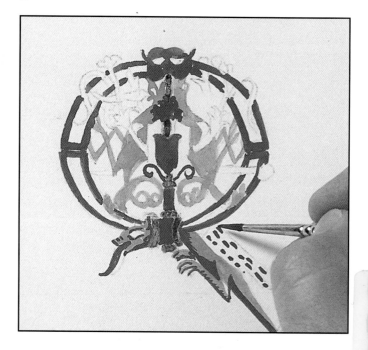

5 Mix a weak mixture of cadmium primrose yellow and ultramarine and paint the background using a No 1 brush. (Alternatively, you could use gold gouache paint for this, which would contrast quite well with the burnished gold.) Note that it is important to do the background first, so that you do not leave any little corners of unpainted white paper showing through.

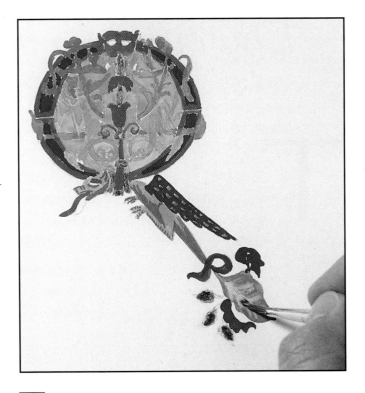

T I P

PREPARING **PVA** GILDING MEDIUM

PVA gilding medium is a pink colour. It consists of a glutinous liquid that contains a thickening agent held in suspension. This tends to settle in the bottle and needs to be stirred up. Do not shake the bottle and thereby make it full of bubbles, however. (If you get bubbles on your paper you should pop them with a pin or brush.) Instead, turn your bottle upside down, end to end, until the medium has been well mixed, or else stir the medium with a brush – but ensure that you do not make any bubbles.

 6 Paint the red areas with flame red and the pink with permanent white added to the red.

 7 Change your water and paint the blue areas with ultramarine. Add a little cadmium primrose yellow to the ultramarine and paint the green areas.

 8 Outline with a mixture of burnt sienna and black and paint the seeds in the pods using a No 0000 brush. Then add the highlights by making a thread-like line on the light side.

 9 Apply the white dots to the blue areas using a No 0000 brush. (Your paint needs to be fairly thick and stiff for this; if it is too wet it will run into the blue.)

Eleventh Century English N

❖ ❖ ❖

This eleventh-century initial is from a Bible illustrated in the Durham style. The poor man is entangled in the snares of life and seems beset by all the cares and worries of existence, which are epitomised by the strange creatures that surround him. Enjoy the challenge of working this delightful initial.

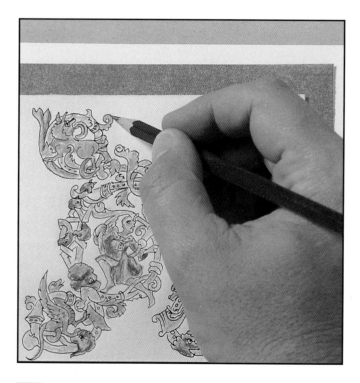

1 Trace the initial with a sharp 2H pencil. Use a piece of tracing-down paper to transfer the image to your project paper. If you pencil over the back with a 6B pencil or scribble extensively over it you will find that it is difficult to see what you are doing when you trace it down.

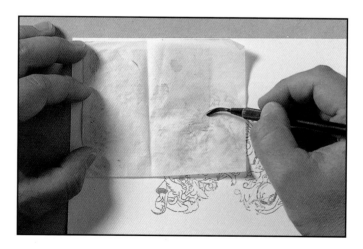

2 Apply the PVA gilding medium to those areas that will be gilded. Allow the first coat to sink in and dry and then apply two or three coats, depending on how raised you want the gold to appear. Allow each to dry before applying the next. Then rub down three coats of transfer gold over the medium, working around the edges with the point of your burnisher. Burnish the gold thoroughly.

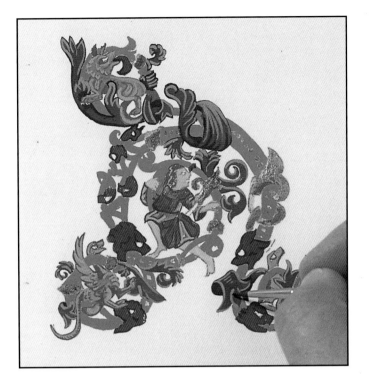

3 Paint the creatures in olive-green, mixed from cadmium primrose yellow, yellow ochre and ultramarine.

4 Outline the creatures in dark-green with a No 0000 brush.

5 Paint the man in the following colours. *Coat*: a mixture of burnt umber, red ochre and yellow ochre; dark tones in burnt umber. *Hair*: a mixture of burnt umber and yellow ochre. *Skin*: a mixture of yellow ochre, flame red and permanent white.

6 Paint the blue areas with ultramarine.

7 Mix a little yellow ochre into your blue colour and paint the green areas.

8 Outline the image in a burnt-umber and black mixture, using a No 0000 brush.

9 Highlight the green areas with yellow ochre and the blue with permanent white. Tidy up the edges with permanent white.

TIPS

TRACING-DOWN PAPER

Tracing-down paper is essentially a sheet of tissue which is coated on one side with a powder (usually red) that comes off when under pressure. You place a sheet of tracing-down paper under your tracing and then go over it again with a sharp pencil. The pressure of the pencil causes the powder to stick to the paper, leaving a copy of the image on it. Take a piece of greaseproof paper and a set of soft chalk pastels. Select a pastel of a contrasting colour to that of your project paper. Rub it all over the greaseproof paper and then rub over it thoroughly with your finger (wrapped in a piece of paper).

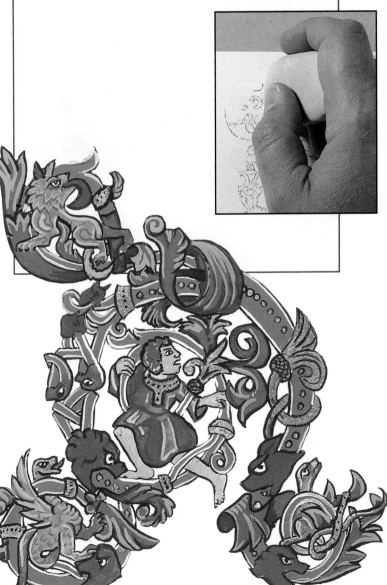

Twelfth Century English I

• • •

This bold capital 'I' has been copied from a twelfth-century English manuscript. I have used it as the basis of my designs for four Christian sacred monograms. Copying them will give you a chance to practise what you have learnt so far and to brush up on your technique.

IHS: the Latin form of the Greek letters *IHC*, the first three letters of the Greek word *IHCOYC*, meaning 'Jesus'.

PX: the first two letters of the Greek word *XPICTOC*, meaning 'Christ' (this may be written in different ways, often with the X on the stem of the P).

AO: Alpha and Omega – the first and last letters of the Greek alphabet. Jesus said 'I am the Alpha and the Omega . . .'

MARIA: the monogram of the Virgin Mary, mother of Jesus Christ.

The treatment of these initials is quite straightforward, but this often has a greater impact than a more complicated decorative scheme. These simply designed capitals can be very useful for secondary initials within a project, such as those used at the beginning of paragraphs and sentences.

By way of an embellishment I have tried to make the middle node of the 'I' look as if it is made of shimmering material.

LIFTING PAINT

The light parts of the nodes were made by lifting the paint off the surface with a squeezed-out brush. Paint the colour, then quickly wash out the brush and squeeze it dry. Next paint over the area that you want to appear lighter, and the brush will suck up the colour, leaving the area looking paler. It is important to be positive when you do this: the more you dither the more ragged and messy the result. You must also be quick, or the pigment will soak into the paper.

PAINT THE AREA WITH MEDIUM STRENGTH COLOUR.

QUICKLY WASH OUT THE BRUSH AND SQUEEZE IT BETWEEN YOUR FINGERS. WITH THE DRY BRUSH, QUICKLY GO OVER THE CENTRE OF THE AREA AGAIN, LIFTING OFF THE COLOUR AS YOU GO, LEAVING A LIGHTER TONE, WITH SOFT GRADUATED EDGES.

PAINT THE OUTSIDE OF THE AREA WITH DARKER FULL TONE COLOUR, WHILE IT IS STILL WET, SO THAT THE TONE BLENDS IN. WHEN ALL IS DRY, CAREFULLY PAINT THE TWO PIECES OF WHITE HIGHLIGHT.

Twelfth Century Flemish E

◆ ◆ ◆

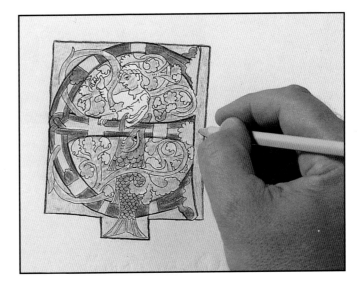

This project is from a twelfth-century Flemish Bible. The illustration shows Jonah being spewed out of the whale's body. Jonah and the whale are incorporated into the capital letter 'E', from the Latin word *et*, meaning 'and'. The cunning combination makes a very telling design. If you can make it half as interesting as this example, you should be pleased with your ingenuity and skill!

YOU WILL NEED

- ❖ Tracing or greaseproof paper
- ❖ Sharp 2H pencil
- ❖ Rubber
- ❖ Gouache paints: ultramarine, brilliant yellow, red, pink-flame red, dark brown, black, gold
- ❖ Transfer gold
- ❖ PVA gilding medium
- ❖ No 1, No 2 and No 0000 brushes
- ❖ Burnisher
- ❖ Paper tube

1 Trace over the design with tracing paper and a 2H pencil, and then trace it onto your project page.

2 Paint the bands on the capital 'E' with PVA gilding medium. You will probably have to apply two coats; allow each coat to dry before proceeding further. Take care to make sure that you paint well into the corners so that you do not leave them ungilded.

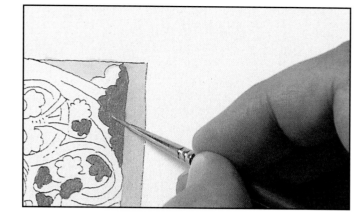

3 While the two coats of PVA gilding medium are drying, carefully paint the gold in the central areas of the big capital 'E', and also in the turned ends of the foliage. (I have additionally embellished the whale with a few gold scales, a gold eyebrow and some gold fins.) You may have to leave all the gold to dry before you can proceed further.

4 When all is dry, have your paper tube, sheet of transfer gold and burnisher to hand. Gently puff through the tube onto the PVA medium on the first strap of the capital 'E', so that the gum in the medium is moistened. Lay your sheet of transfer gold onto the strap, placing the edge of the gold as close to the edge of the design as possible. Holding the paper still with your spare hand, burnish the backing paper over the strap with even, circular strokes. Repeat the process with each of the other straps, working from the top downwards. When all the straps are done, burnish directly onto the gilded areas until a deep shine is produced.

5 Mix a pale solution of ultramarine and brilliant-yellow and dilute it with enough water to obtain the correct colour. Paint the pale-green area outside the initial.

6 Paint the red and blue areas carefully. Mix a little pink-flame red with lots of water to dilute it into an appropriate colour.

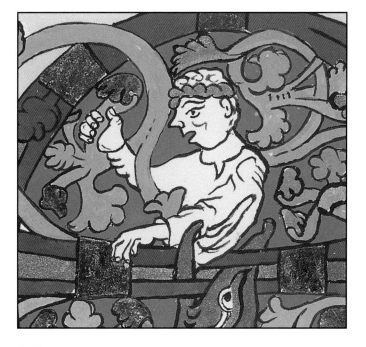

7 Paint the whale in your own mixture of brown gouache.

8 Mix some dark-brown and black gouache to make a thin, creamy consistency and outline the image. Leave Jonah unpainted.

9 The brown colour which I painted on the whale looked boring, so I mixed up some gold gouache with water and gave the whale a weak wash. I felt that this added considerable richness to the whole composition. (Remember, when you do this, to leave the eye white, which gives it a piercing brightness.)

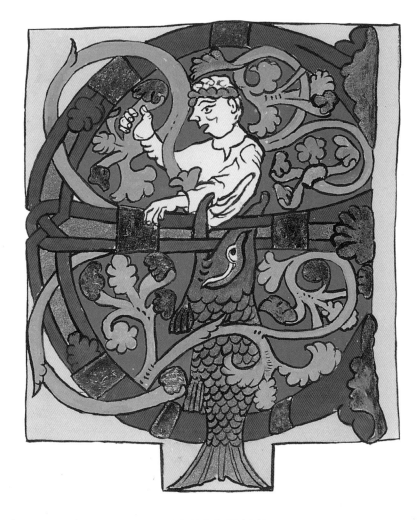

Fourteenth Century French T

❖ ❖ ❖

he little miniature used in this capital letter comes from a fourteenth-century French manuscript. This method of design is such a common feature of the decoration of letters from the fourteenth-century onwards that it is worth trying to emulate it.

You will have to make up your own mind about the little monk. Is he the cellar master making sure that his brew is fit to be placed before the abbot, or is he taking the opportunity to have a swift draught himself?

This letter is straightforward in its treatment and, provided that you take each step at a time and that you are thoughtful and patient, you will be surprised at how well you progress.

1 Make a tracing of the image and transfer it to your project page. When you draw the barrel, make sure that you preserve the rounded shape of the staves and hoops.

2 First paint the miniature. Mix a little black and burnt umber with enough water to make a weak mixture and paint the background of the dark cellar.

3 With a wash of burnt umber, paint the barrel, the stand and the archway. With a squeezed-out brush, quickly lift the colour off the top of the barrel and then paint a second coat onto the underside of the barrel. With a squeezed-out and rewetted brush, blend the dark and light shades together so that the barrel appears round. Paint the stonework on the arch with a second coat of burnt umber; also paint the jug with the same colour.

4 Take a little black and mix it with water to produce the pale tone of the monk's habit. Paint the habit all over and, while it is still wet, paint the dark tones, blending and softening them a little with a clean, wet brush to show the folds. Paint the hoops of the barrel with the same shade of black, lifting the colour off the top with a squeezed-out brush to make these areas look lighter and preserve the rounded effect.

5 Mix a touch of red and yellow to make the skin colour and paint the hands and face. A second coat under the chin and where the arm protrudes from the sleeve will provide shadow.

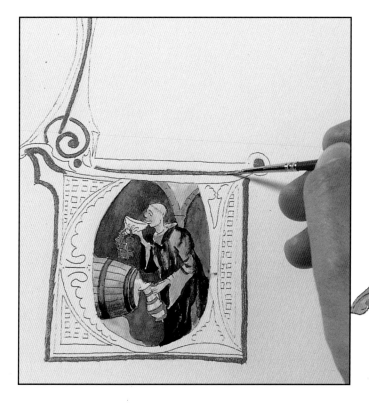

6 Paint the gold areas, including the keys and the hoops on the jug, with gold gouache.

7 Paint the red and green areas, taking care with the little green squares around the initial letter.

8 Mix some ultramarine and permanent white to make a pale blue and paint the whole initial, leaving a thin white line between the blue and the red.

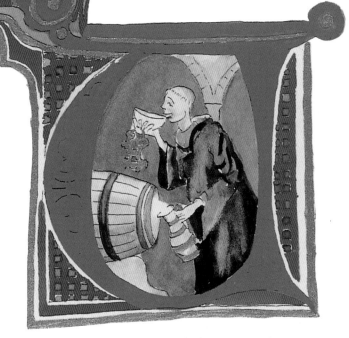

9 With neat ultramarine, paint the dark-blue parts of the image.

10 Mix some permanent white with water until it is the consistency of thin cream. Paint all the white lines on the blue areas and also between the other colours, painting over the gaps that you left. Note that the little green squares are highlighted with white at the bottom and on the right-hand side. (Correct any wiggles using the colour that the highlights are painted on.) Be patient with the white dots on the red: if they are placed correctly, they will lighten the tone.

11 Mix some black and burnt umber to make a dark brown and outline everything. Paint the shadowed top and left-hand side of the little green squares.

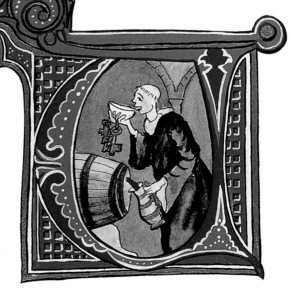

TIP

DEALING WITH SPLODGES

If you get paint in the wrong place when using gouache, it is possible to remove it. Wet the offending spot and gently stir it with a brush until you see the paint lift up from the surface. Squeeze out your brush and pick up as much as you can. Repeat the process as often as possible, but be careful not to damage the surface. When you feel that you can do no more, leave it to dry, but first try blotting out the last attempt with a tissue or some blotting paper.

When it is completely dry, paint over it with a strong coat of permanent white, which you should lay on gently to ensure that you do not mix in any of the offending pigment that lies below. Allow to dry. When it is totally dry, repaint the lost image, taking care to lay the colours on gently so that you do not disturb the permanent-white pigment lying below.

Fourteenth Century English I

• ◆ •

This amazing capital 'I' comes from the Luttrell Psalter, which was written in the fourteenth-century for Sir Geoffrey Luttrell, a Lincolnshire knight. I have copied this letter because of its bizarre extravagance. You can certainly enjoy stretching your painting and drawing skills with this!

The lesser initials have also been included to make the point that it is not only the great capital letters that interest us. The other capitals that appear on the page can be given a decorative treatment as well, in varying degrees according to their importance. These capitals,

drawn in a fat, Lombardic style, are plainly drawn and simply coloured, but are made more significant by the pen-drawn decoration that surrounds them, forming white dots and a trifoliate decorative design. At first sight this looks rather complicated, but provided that you keep calm it is actually quite straightforward. If you draw round the letters, leaving a white line and drawing round the trifoliate leaf shapes at the appropriate places as you progress, you will find that it is not as difficult as it first seemed. Next draw the irregularly scalloped outer edge, and you subsequently only have to fill in the rest carefully, leaving out the little white dots as you do so.

1 Trace the large capitals and, if you want, also the lesser capitals.

2 Transfer the image to your project paper with a sharp pencil.

3 Ink in the lesser initials, leaving the colouring until last.

YOU WILL NEED

❖ Tracing or greaseproof paper
❖ Sharp pencil
❖ Ink or gouache paints: brilliant yellow, yellow ochre, burnt umber, light red, ultramarine, black
❖ Brushes

4 This project has been drawn in ink, but there is no need to ink the main design. Make a thin wash of brilliant yellow and water and wash over the top half of the character. Leave the eye white. Squeeze out your brush and lift the highlights off the beak, forehead, cheek and folds of material. Paint the tail.

5 While the yellow is still wet, mix yellow ochre and a little burnt umber and paint the dark parts on the back of the head and the folds.

6 With a weak solution of light red and water, blend the dark tones with the lighter yellow, lifting off paint to provide the modelling on the face and the folds of the cloth.

7 Paint over the tail with the same brown-reddish colour.

8 Paint a light wash of ultramarine and water over the lower half of the creature and quickly lift off the highlights on the face and the leading thigh. Leave the eye white.

9 Paint the dark parts with neat ultramarine and blend it with the light parts with a wet brush, lifting off paint if needed.

10 Paint the white lines, dots and circles on both halves of the creature and on the flowers.

11 Make a soft and creamy mix of black and burnt umber and carefully paint the outlines. Place a dot of the mixture in each circle.

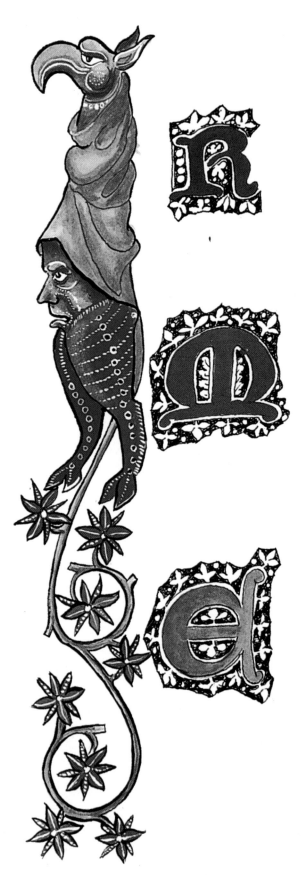

Sixteenth Century English S

• • •

This capital 'S' is striking in the imagination of its design and in the vigour of its style. The interwoven strapwork is typical of the penmanship of the sixteenth century. It appeared on an uncoloured document, the capital being simply drawn with a pen.

USING COLOURED PAPER

You can produce some very striking effects with coloured paper. There are some problems that you should be aware of, however. If you are tracing down a design you may find that the red tracing-down paper does not show up. In this case, make yourself a sheet of contrasting colour with some greaseproof paper and a chalk pastel of an appropriate colour. To do this, lay the pastel on its side on the greaseproof paper. Rub it all over the sheet to get as even a colour as you can. Then wrap a piece of paper around your finger and rub it all over the greaseproof paper, spreading and working in the pastel until the surface of the greaseproof paper is completely covered.

YOU WILL NEED

❖ Sharp 2H pencil and a 6B pencil

❖ Tracing paper or tracing-down paper

❖ Brushes

❖ Gouache paint: pale green, ultramarine, cadmium pale yellow, permanent white, flame red, gold, black, burnt umber

❖ Pen and ink

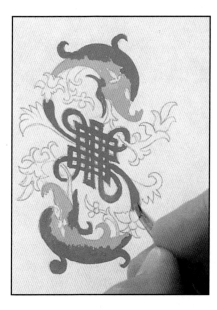

1 Trace the design with a sharp 2H pencil and then go over the back with a fairly sharp 6B pencil.

2 Mix some pale green with ultramarine, cadmium pale yellow and water. Paint the head and lower body of the two dolphins.

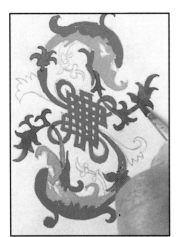

3 Mix some light blue, permanent white and ultramarine and paint the top of the back, the bottom jaw and fin and tails.

4 Paint the tongues and small mid sections with a light red.

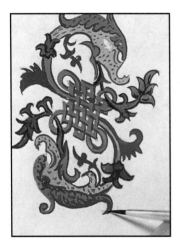

5 Paint the dark colours on the green, blue and red areas, and the fins and tails with dark blue.

6 Paint the gold areas with gold gouache, carefully placing the dots on the interwoven section.

7 Make a soft and creamy mix of black and burnt umber and carefully outline the whole image, taking particular care over the interwoven areas.

8 I have drawn the interwoven areas separately in pen and ink. It makes it easier to see the pattern and is also handy to keep for future reference.

TIP

STRAP WORK

Strap work is a very common and attractive element of designing letters and borders and has been used in different styles over the centuries. At first sight it looks very complicated, but patiently follow each part through. It helps to remember that the design is often formed by two interlacing parts combining from different directions. Sometimes a third, unconnected, unending strap is interlaced with the two ends. If you like these designs, it is worth collecting tracings and keeping them in a scrap book for future reference and adaptation.

Fourteenth Century D

❖ ❖ ❖

This capital 'D', copied from a fourteenth-century manuscript, shows the amazing beauty and simplicity of form of the Lombardic capitals, and also emphasises their suitability for decorative treatment. The treatment and design is quite simple and straightforward, but the effect is brilliant.

It is a good idea for you to get into the habit of drawing initials freehand and, if you are not doing this already, this is a simple project which gives you a chance to try out your ability. Once you can do this, your work will become much more spontaneous, and will also have your own stamp on it rather than mine. Another advantage is that you can easily make the capitals whatever size you want, without having to go to the trouble of enlarging or shrinking the design.

YOU WILL NEED

❖ Pencil

❖ Tracing paper

❖ Gouache colours: light blue, ultramarine, permanent white, red, green, gold, creamy white, black, burnt umber

❖ Brushes, including No 0000 brush

1 Trace, transfer and colour in as before.

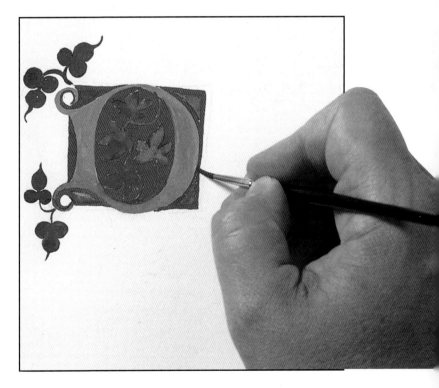

2 Paint the blue areas.

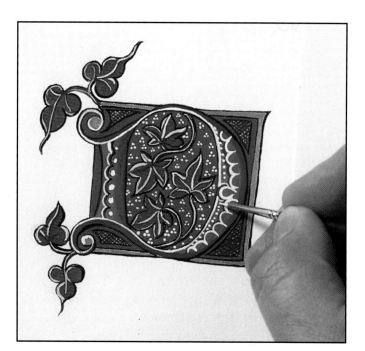

3 Paint the red and green areas.

4 Paint the dark-blue areas with neat ultramarine and then, with a clean, wet brush, blend the light and the dark areas to try to give the effect of a rounded surface.

5 Paint the gold border and roundels in the finials with gold gouache.

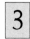

6 Mix some soft, creamy white with permanent white and water and, using a No 0000 brush, carefully paint all the highlights on the blue and green leaves.

7 I felt that the four green triangles looked too plain, so I painted a diagonal cross-hatching over them in a darker green. This made them look more interesting, but still very dull. To alleviate this, I painted a very tiny gold dot into each diamond and was very pleased with the result. You could do the same.

8 I thought that the centre of the letter looked too dull, so I painted the white dots in groups of three, adding only one where there was not enough room for three. This made the middle look more interesting and also much brighter. You might wish to do the same.

9 Mix some black and burnt umber into a runny, creamy consistency and carefully outline the image, tidying up with permanent white as you go.

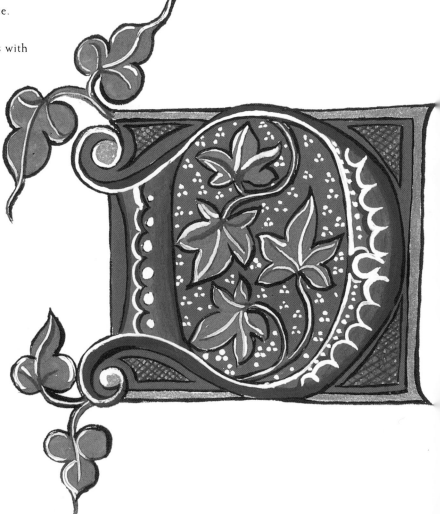

Fifteenth Century Border

♦ ♦ ♦

This project is something of a summing-up exercise, and presents an opportunity to test what you have learned so far with a complete project. I have chosen this particular prayer because it is probably the only piece of prose that is known to almost everyone. I have chosen to write it in Latin, because although this is now regarded as a dead language, it is nevertheless still used universally. If you do not like the idea of writing in Latin, try it in your own preferred language. You could also use another short item of text that you know well; the important point is that you choose something that you are very familiar with, so that you do not have to think about the words. The border that I have used is taken from a fifteenth-century French model, and the capitals have been adapted from an example of work from the same period.

LAYOUT

You will first have to decide upon the size and shape of paper you are going to use. You will next have to think about the amount of decoration you wish to apply, and how much of your efforts will be devoted to the text, capitals and decoration.

Make the size of your capital letter relate to the writing lines: the size is up to you, but if it does not match the lines it will look odd. You need to establish how much room you will have for writing your text. If the text is very wordy, you may have to spend some time working out how you are going to fit it onto the page, and then see how much space is left for decoration and capital letters. As these projects are about capital letters, however, it would be better to chose a text that displays them to good advantage. You will have to decide how many lines will be needed to accommodate the words, and you may have to make several drafts on rough paper before you have a satisfactory layout.

Having worked out the number of lines you will need, you then have to rule up the available space to accommodate your words within the required number of lines within the decorated area, leaving enough space between each pair of lines of text for the ascenders and descenders. Now chose a nib that will give you lettering of the right size to fit the lines, working on the basis of four or five nib widths for the body of the text.

A

You will next need to consider how you are going to arrange the words within the lines on the page. They can be aligned to the left (A)- or right-hand margin (B); both approaches look effective, especially when combined with a scheme of decoration that emanates strongly from one side or the other. You could also centre them (C). This looks good, too, and will allow you to employ a symmetrical scheme of decoration which is the same on both sides of the text. It is quite difficult to get this right, however. Count the letters and spaces in each line (allow one character space equivalent to the letter 'n' between each word), then find the middle of the line and mark this on the centre of the line on your page, spacing out the rest of the characters of the line on either side of this. Do the same with each line. (If you have a computer, you can, of course, command it to do this for you. Provided that you can print it out in the same size that you are going to use to write the text, you can simply trace off the layout, which will be perfectly correct.)

B

C

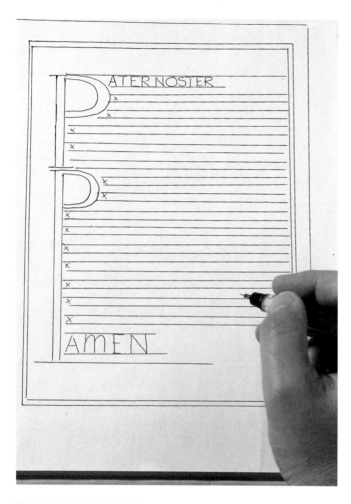

 1 Once you have worked out all your rulings on a sheet of rough paper, place this on your project page and trace them down lightly.

2 Before you start transcribing your text, carefully spell out the alphabet on a piece of rough paper and put it on a board in front of you. This will help you to focus your brain and hand on the job and will give you time to make sure that your pen is working properly.

3 When you are satisfied that all is well, try to write all the piece in one go; it will improve the continuity of your letter forms.

4 Provided that you have used waterproof ink, you will be able to make some corrections to ill-formed letters with permanent-white gouache.

5 Once you are satisfied with your text, put it away to make sure that it is thoroughly dry before applying the decoration.

6 Draw in the capitals and decoration in the spaces round your text.

YOU WILL NEED

- ❖ Rough paper
- ❖ Project paper
- ❖ Waterproof ink
- ❖ Pen
- ❖ Pencil
- ❖ PVA gilding medium
- ❖ Paper tube
- ❖ Burnisher
- ❖ Gold leaf
- ❖ Gouache paints: green, red, blue, dark red, dark green, dark blue, white, black, burnt umber
- ❖ Brushes, including No 0000 brush

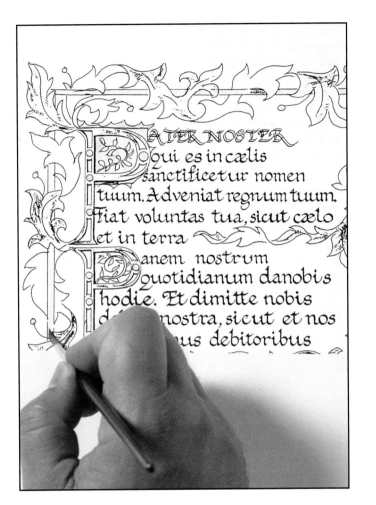

7 Paint on PVA gilding medium in two coats, allowing each to dry completely before proceeding with the frame, the centre of the main capital and the berries.

8 Working from the top downwards, take your paper tube and breathe onto the medium to moisten it. Rub down two coats of gold leaf onto each gilded part, burnishing them carefully through the backing paper before you proceed further.

9 Gently but thoroughly burnish each gilded piece until it takes on a dark shine.

10 Paint the two pieces of green decoration. As you paint them, also lift off a sweep of pigment from the centre of each part of the leaf so that it is highlighted.

11 Paint the leaves in the centre of the top initial and also paint the centre of the lower initial, but in this case leaving out the leaves.

12 Paint the red letters of the 'Pater Noster', the two capitals and the 'Amen', as well as the leaves in the lower capital.

13 Paint the blue decoration, lifting out the colour in the centre of the leaves as you proceed. You will need to do this quickly, or the paper will become stained.

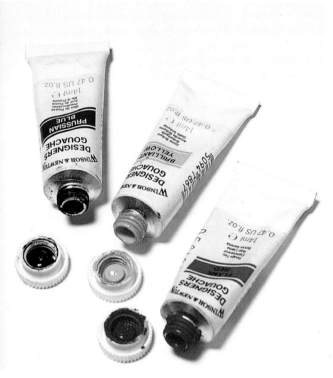

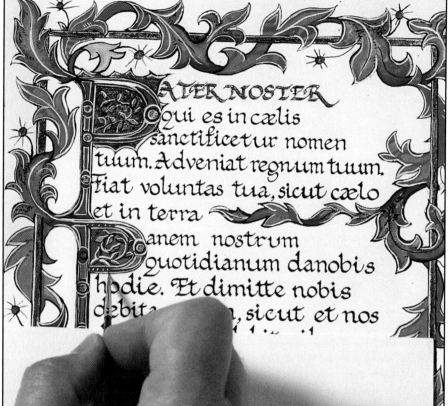

 14 I decided that I did not like the green centre of the second capital, and that I would rather gild the 'Pater Noster' than have it in red, so I did another version, making the centre red, the leaves green and gilding the letters.

 15 Paint the red decoration, lifting off the pigment in the central areas as you go.

 16 With some dark red, dark blue and dark green, work around the decoration as appropriate, painting in those parts that should really be in shadow.

 17 Take some permanent-white gouache and a No 0000 brush and work over the whole project, painting in the highlights.

18 With a black and burnt-umber mix, outline the work, painting in the whiskers on the berries to make them stand out more.

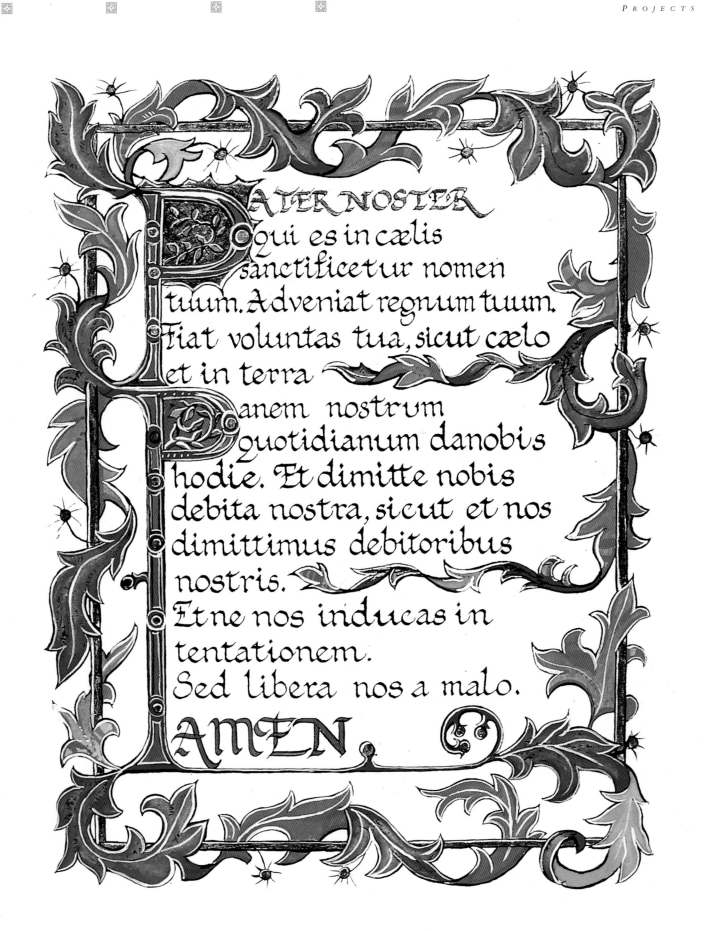

PATER NOSTER
qui es in cælis
sanctificetur nomen
tuum. Adveniat regnum tuum.
Fiat voluntas tua, sicut cælo
et in terra
panem nostrum
quotidianum danobis
hodie. Et dimitte nobis
debita nostra, sicut et nos
dimittimus debitoribus
nostris.
Et ne nos inducas in
tentationem.
Sed libera nos a malo.
AMEN.

Fifteenth Century White Vine

❖ ❖ ❖

This style of design, known as the 'white vine', first appeared in the tenth century. It became very popular on its reappearance in Italy in the fifteenth century. The pen-drawn vine-and-leaf design is picked out in different colours and is enhanced by the colours that surround it. The vines were usually left white, but some were coloured cream and some green; some were even multi-coloured, especially when the vine design was drawn as a geometric spiral. The design was often drawn both within the letter and spreading round it and down the page.

1 Take a piece of tracing or greaseproof paper and draw two horizontal lines (between which the inscription will be written) and two vertical lines (which will contain the vine design). Draw in the lettering, the outlines of the capital letter and the design. Retrace and alter as often as you feel necessary to achieve the size and shape that best occupies the space.

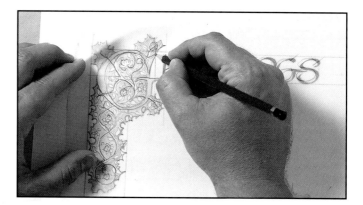

2 Draw the vine design in detail, making sure the tracing paper does not move.

YOU WILL NEED

❖ 2H pencil

❖ Tracing or greaseproof paper

❖ Project paper

❖ Tracing-down paper

❖ Rubber

❖ Ruler

❖ Masking tape

❖ Nos 1 and 0000 brushes

❖ PVA gilding medium

❖ Paper tube

❖ Gold leaf

❖ Burnisher

❖ Gouache paints: ultramarine, blue, red, brilliant yellow, yellow ochre, gold, black, burnt umber

❖ Waterproof ink

❖ Lettering pen

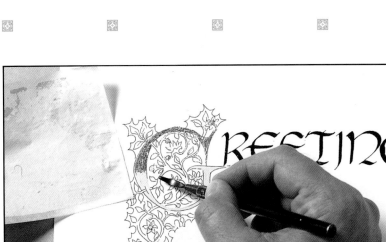

 3 Rule two guidelines (for the lettering and design) on your project paper. Using waterproof ink and a lettering pen, write the word, leaving out the capital. Trace down the capital letter and design.

4 Paint two coats of PVA gilding medium onto the capital letter, flower centres and little buds. Allow each to dry.

5 Breathe on the area to be gilded through the paper tube to make the medium sticky and lay the gold leaf onto the form, rubbing it down with a burnisher.

 6 Paint the blue and the red areas.

7 Paint the green areas with a mixture of brilliant yellow, yellow ochre and ultramarine.

8 Paint the gold areas on the outside of the initial and the vine area, making sure that the gold gouache is thick enough.

9 Outline everything with a mixture of black and burnt umber. Apply spots of gold leaf to any bare patches in the gilding and reburnish if necessary.

Using the same design, I have written a different word, taking some liberties with the text to make it fit in the space. I have also experimented with the colour pattern to give a stained-glass effect. Instead of gold leaf I have used gold paint on the initial and have also experimented with outlining in gold paint.

Salut

10 'Greetings', written in French. I have used the same tracing, adapting it to a capital 'S'. I have painted the whole design in the one colour. The effect is so strong that I did not outline it – even adding gold to the buds and flower centres would diminish the impact.

Grüssdich.

11 'Greeting', written in German. I again used a single colour for this (the green was mixed from ultramarine and yellow ochre).

Fifteenth Century French A

· · ·

This initial was adapted from a fifteenth-century French manuscript and relies mostly on penwork for its effect. The drawing and painting of the initial are simple tasks, but the penwork around the initial and in the stem needs a little thought. I drew it with a technical drawing pen, but a mapping pen would do just as well. It is important both to make all the hoops the same size and to produce fine lines.

When I first looked at this initial, I was attracted by its design possibilities. According to the demands of the text, the stem could be made any length and the branches could be placed in any suitable position. The design could be adapted to fit a left- or right-hand margin or could go in the middle of the page, while a small miniature or heraldic device could be used in the place of the initial.

YOU WILL NEED

❖ Tracing paper
❖ Project paper
❖ Pencil
❖ Ruler
❖ Right-angled set square
❖ Compasses
❖ Rubber
❖ Mapping pen
❖ Waterproof ink or gouache paint

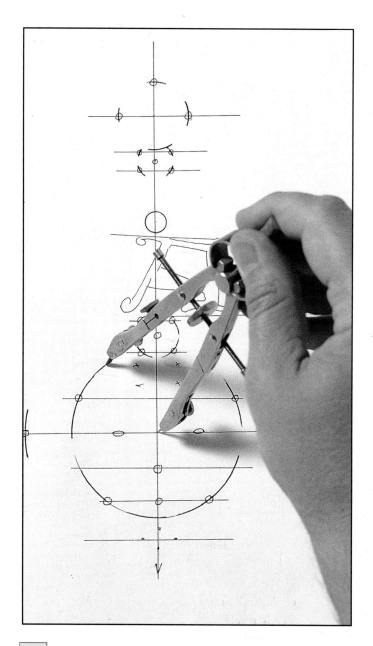

1 Draw a vertical line on a piece of tracing paper to act as the backbone of the design. Draw in a series of crossbars, making sure that they are at true right angles to the stem. Using your compasses, draw a series of circles centred on the stem. Rub out the part of the stem where the capital letter will go.

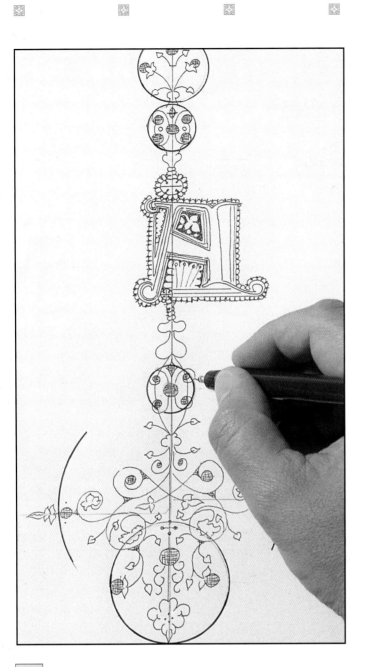

2 Trace down the design onto your project paper.

3 To do the penwork, you will need waterproof ink of your chosen colour or gouache paint. (If you are using gouache, mix it with water and and transfer it to your pen with a brush.) Draw the initial and the surrounding penwork.

4 Draw in the design, trying to keep the work as fluid and neat as you can. Then, to finish, colour the initial.

Fifteenth Century Q

• • •

This project is copied from a fifteenth-century musical score. I was attracted by the miniature – what is it all about? In any event, the capital 'Q', which is simply drawn in gold strapwork and is decorated with acanthus leaves and pen-drawn 'stamens', makes a very attractive project. It does, however, need to act as the frame for a miniature illustration of some kind, but whether you copy this one or devise and execute one of your own is entirely up to you.

1 Make a tracing of the image and trace it down onto your project paper, ensuring that it is upright.

2 Paint the PVA gilding medium onto the capital letter with the No 1 brush and allow thirty-five minutes for it to dry.

3 Puff a breath through the paper tube onto the top of the letter. Lay the gold leaf on the area that you have just moistened. With the burnisher, rub over the area so that the gold adheres to the letter and is detached from the backing paper. Work all round the letter and down the tail, making sure that you do not rub away the area that you have just completed.

YOU WILL NEED

❖ Tracing paper

❖ Greaseproof paper

❖ Tracing-down paper

❖ 2H pencil

❖ Project paper

❖ Gouache paints: gold, red, ultramarine, permanent white, black, burnt umber

❖ Watercolour paints: burnt umber, Prussian blue, crimson lake

❖ Nos 1 and 0000 brushes

❖ PVA gilding medium

❖ Paper tube

❖ Gold leaf

❖ Burnisher

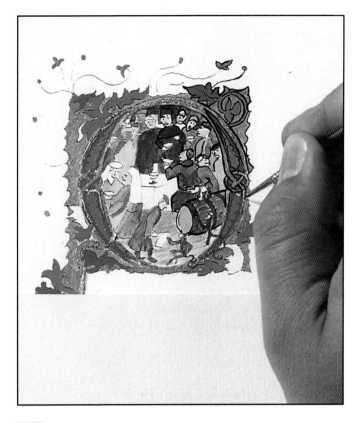

4 Paint the gold gouache (diluted to the right consistency) on the outer parts of the design.

5 Paint the red and blue areas, as well as the fat cardinal at the top of the group.

 6 Paint the miniature with watercolours. Start by painting the dark area at the top, behind the heads, with a mixture of burnt umber and Prussian blue. Then paint the floor with light brown, along with the barrel, darkening the paint with a little burnt umber. Darken the fat cardinal's colour with some crimson lake, and then paint the rest of the figures, working from the largest parts to the smallest. Finally, paint the animals.

7 Outline the image with a mixture of black and burnt-umber gouache, as well as some of the figures in the miniature.

 8 Highlight the blue areas with some permanent white. Use a No 0000 brush and make sure that the paint is the consistency of thin cream.

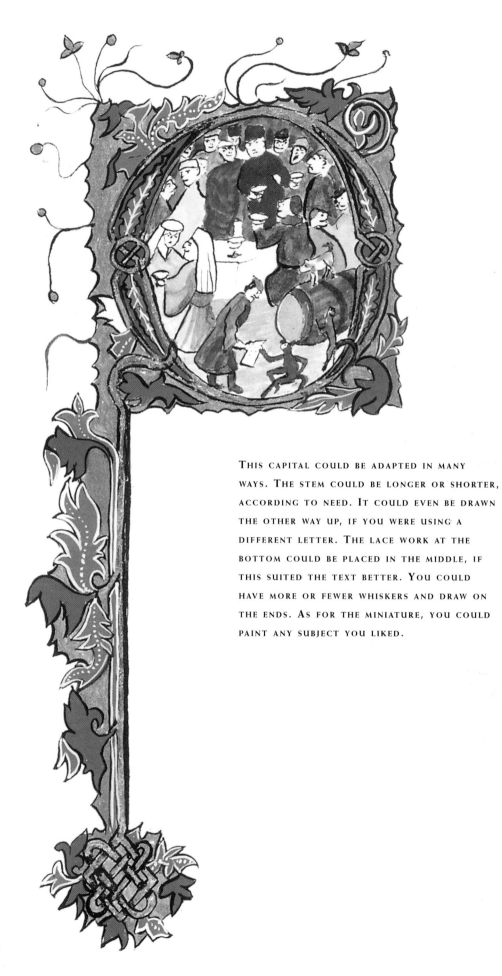

This capital could be adapted in many ways. The stem could be longer or shorter, according to need. It could even be drawn the other way up, if you were using a different letter. The lace work at the bottom could be placed in the middle, if this suited the text better. You could have more or fewer whiskers and draw on the ends. As for the miniature, you could paint any subject you liked.

Fifteenth Century K

❖ ❖ ❖

This exotic pink 'K' is taken from another fifteenth-century musical score, this time from a French book of hours. Although it looks quite large here, it would originally have been drawn much smaller than this. Books of music were placed on a stand for a choir of monks to gather around; books of hours, however, were very small and could be slipped into a pocket. This capital letter starts a prayer of supplication – 'Lord have mercy' – that would have been sung in Greek at the beginning of every Mass.

I have included this project to introduce the effect of raised gold and also to point out some interesting developments that occurred while I was experimenting with different materials.

1 Make a tracing of the image and trace it down onto your project paper. If your image is sharp enough, you will not need to draw over it.

2 With a No.1 brush, take up some prepared gesso and paint round the form, taking care to paint into the points and corners. Now take a good brushful and start to fill in the form. Pushing, rather than painting it, gradually work over the form, filling in the area with gesso, so that any surface irregularities are removed. Work from the top downwards. When you have finished, put your work away in a warm spot to dry for at least a couple of hours.

YOU WILL NEED

❖ Tracing or greaseproof paper

❖ Tracing-down paper

❖ Project paper

❖ 2H pencil

❖ Rubber

❖ Gouache paints: permanent white, ultramarine, alizarin crimson

❖ Gesso

❖ PVA gilding medium or spirit-based gilding medium

❖ Nos 1 and 0000 brushes

❖ Gold leaf

❖ Paper tube

❖ Burnisher

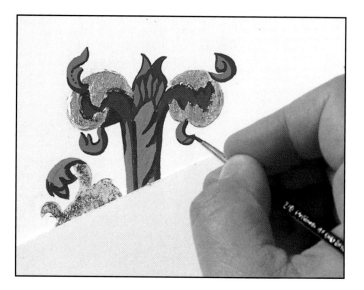

3 When the gesso is smooth and hard, paint a coat of gilding medium over it. Leave it to dry. (If you use PVA gilding medium, you will find it difficult to paint a thin coat without leaving brush marks, which will show through the gold leaf and spoil the mirror-like surface for which you are aiming. You may prefer to buy a prepared, spirit-based gilding medium which dries quite smoothly, leaving no brush marks, but takes several hours to do so. If it is painted directly onto the paper, it makes it look transparent, so take care round the edges of the form.)

5 Paint the letter as follows. (Keep a piece of paper under your hand to prevent damage to your gilding.)

The light-blue parts: with a permanent-white and ultramarine mixture.

The pale-pink part: with an alizarin crimson and permanent white mixture.

The dark-blue parts: with neat ultramarine.

The dark-pink parts: with neat alizarin crimson.

Highlighting: highlight the pale-blue and pink parts with permanent white.

This letter is not outlined. If you want to do so, I suggest that you outline the pink areas with madder carmine, the blue areas with Prussian blue and the gold areas with a black and burnt-umber mix.

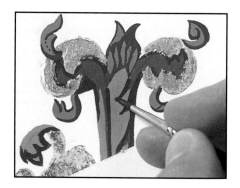

4 Breathe through the paper tube onto the medium at the top of the page to moisten it. Lay the gold leaf on the area and burnish the backing paper. Rub down another layer of gold to make good any splits. When you have finished, burnish the gilded work through a piece of tracing paper, working over and round each piece. Then burnish the gold directly.

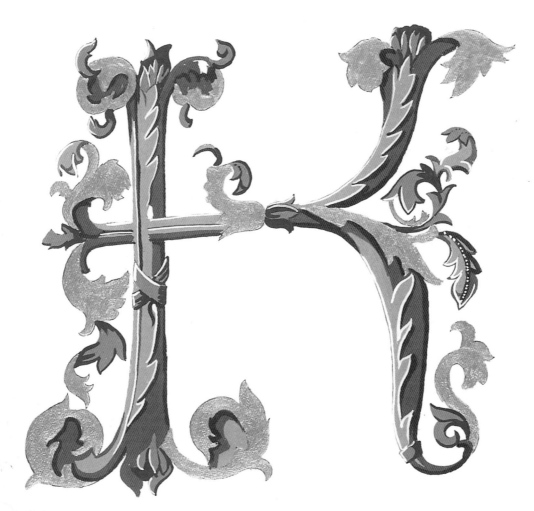

TIP

GESSO

Gesso, (which is made of plaster of Paris or a similar material mixed with a binder), is painted over the area to be gilded, leaving a raised area. When it is dry, gold leaf is applied to it. The gilded raised form glitters and catches the light, illuminating the page. You can make gesso yourself, but if you will only be needing a small quantity use ready-made acrylic-based gesso that you can buy in small jars.

If you are going to apply gesso, the secret is to lay a smooth, even base coat. When you open the jar, you will see that it contains a thick, white, cream-like substance which will need to be diluted with water if it is to be used for lettering. If it is too thin and runny, it will not stand proud of the paper. If it is too thick, you cannot lay it

smoothly. By constantly adding a little more water you can get the right consistency. Dip a brush into the gesso and lift it out, letting the water drip back onto the mix. If the water sits on the surface, the mixture is too thick, so add a couple more brushfuls of water. Keep on testing and adding water, until the drip settles into the mix. When the mix has reached this stage, it is ready to use.

Fifteenth Century Borders

❖ ❖ ❖

These two borders are taken from a fifteenth-century manuscript, and show how two dissimilar designs can be combined on the same page. They are relatively simple in composition and can be adapted, lengthened or shortened according to the needs of the project in hand.

The left-hand border, the inner one, is composed of acanthus-like elements that have been expanded to resemble heraldic mantling, with gold fruits and a ribbon winding round them. It has an uncomplicated dignity and could be used on either side of the page, or even between two columns of text. The ribbon could display a motto, piece of text or message. The little escutcheon at the top could carry an heraldic device, monogram or miniature.

You Will Need
❖ Tracing paper
❖ Project paper
❖ 2H pencil
❖ Ruler
❖ Gesso or PVA gilding medium
❖ Brushes
❖ Gold leaf
❖ Paper tube
❖ Burnisher
❖ Gouache paints: yellow ochre, permanent white, black, burnt umber, colours of your choice
❖ Pen
❖ Waterproof ink

1 Either trace the design onto your project page or draw it yourself. If you do the latter, rule a centre line and mark it at regular intervals to show where the top of the ribbon crosses it. Rule guidelines to the left and right to make sure that the acanthus leaves and gold fruits are the same width either side and all the way down.

2 Apply gesso or PVA gilding medium to the fruits. (If you use PVA, resist the temptation to apply a fat drop of it, which will shrink and wrinkle as it dries. Instead apply two or three coats.) Burnish on the gold leaf, starting at the top and working down.

3 Paint the ribbon to make it look as if it is made of a lustrous material, at least on the front side. Make a wash of yellow ochre and paint each section, lifting off the colour in the centre by squeezing out your brush and soaking up the colour before it has soaked into the paper. You could also apply some clean water to the centre and lift it off. Treat each section in turn in this way. Mix a little of your wash with more yellow ochre to make it darker and paint two or three small vertical stripes at either end of each section. Finally, paint a thin strip of neat ochre at the downhill end of each section, to give the illusion of shadow. You could treat the reverse of the ribbon in the same way; this one has been painted blue, but you could chose a different colour.

4 When all is dry, write your text. Remember to write the letters at right angles to the direction of the ribbon, not vertical to the page.

5 Paint the acanthus leaves in the colour of your choice. A useful tip is to mix your main colours with a little white, making them paler in tone. You can then use the neat colour to apply the darker shadow tones.

6 Highlight the outward-rising curves of the acanthus leaves with permanent white.

7 Outline the image with a mixture of black and burnt umber. Remember to paint in the 'eyelashes' round the fruits.

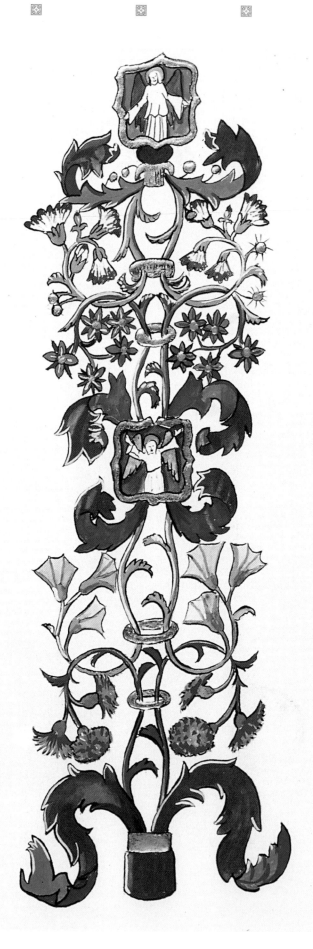

Fifteenth Century P

❖ ❖ ❖

This initial has been adapted from a fifteenth-century missal and displays a flamboyant Lombardic capital 'P', as well as some delicate filigree pen decoration. I have also drawn the coat of arms of the city of Paris within the P. This is a very good way in which to display heraldic devices. The rest of the word is written in the Ronde style, a round letter form used in the French tradition, but you could use any other style that suited your particular project.

1 Rule lines on your project paper to contain the word and capital. If you intend to include any other text, rule the lines for that, too, and write the text.

2 Make a photocopy of your design, and use it to work out your colour scheme

3 Make a careful tracing of the capital and transfer it to your project page. Draw the black penwork in waterproof ink around and outside the letter.

YOU WILL NEED

- ❖ Tracing paper
- ❖ Project paper
- ❖ 2H pencil
- ❖ Ruler
- ❖ Mapping or technical pen
- ❖ Black waterproof ink
- ❖ Gesso
- ❖ Brushes
- ❖ Gouache paint: yellow, ultramarine, permanent white, red, black, burnt umber
- ❖ Gold leaf
- ❖ Paper tube
- ❖ Burnisher

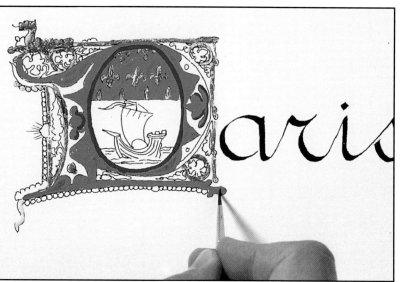

4 Paint the area to be gilded with gesso, pushing it into place with your brush and filling all the little points and corners. (The little fleurs-de-lis on the coat of arms are particularly fiddly, so you may prefer to paint these in yellow paint.)

5 Apply the gold leaf with the burnisher.

6 Mix some ultramarine and permanent white gouache and paint the blue areas.

7 Using neat ultramarine, paint round the inside of the centre of the 'P', shading outwards and then, with a wet brush, blending it into the pale blue area.

8 Paint the red areas.

9 Outline the image with a mixture of black and burnt umber. Highlight the blue areas with permanent white.

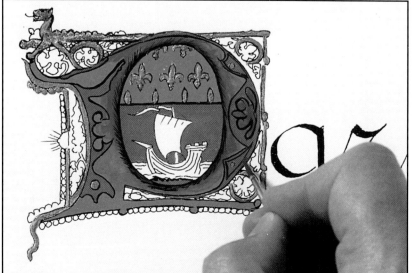

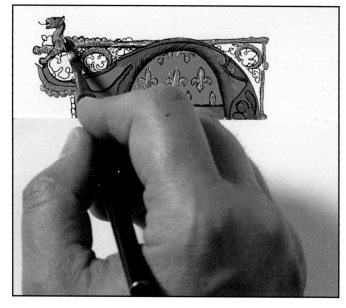

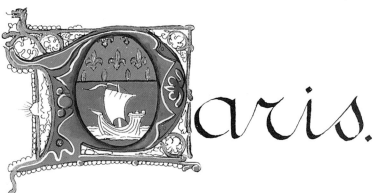

Fifteenth Century English Border

❖ ❖ ❖

This project involves a capital letter taken from a fifteenth-century poem about St Edmund, which is thought to have been written in the scriptorium of the abbey at Bury St Edmunds. The decorative elements are fairly simple, but their effectiveness depends on a crispness of execution. The work needs to be done with flair and panache.

You Will Need

❖ Tracing paper

❖ Project paper

❖ 2H pencil

❖ Gesso

❖ PVA gilding medium

❖ No 1 brush

❖ Gold leaf

❖ Paper tube

❖ Burnisher

❖ Gouache paints: gold, red, ultramarine, green, brown, black, burnt umber, permanent white

1 Trace the image and transfer it to your project paper. (Remember that this should serve only as a guide.) The position of the box for the second capital depends on the text.

2 Mix a little PVA gilding medium with gesso and apply a drop of the mixture to each berry using an old No 1 brush.

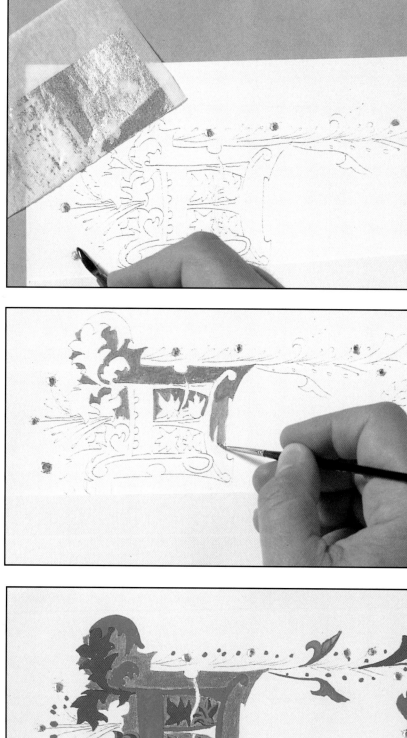

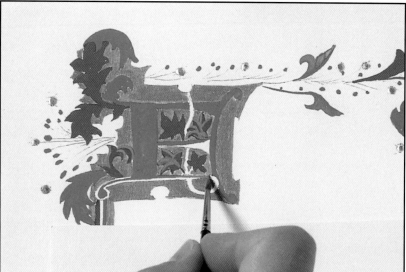

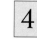 Breathe through the paper tube onto each berry in turn, starting at the top of the page. Take a sheet of gold leaf and, using the burnisher, rub it down over each berry.

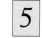 Apply gold paint round the capital and down the stem.

 Paint the blue, red and green areas, having first mixed a little white with each colour.

 Paint the blue of the capital. Mix a lighter shade of the blue and paint the lighter part of the capital and the other light-blue areas. Paint the blue tips of the stamens.

 Outline all the areas of colour with the appropriate, undiluted colour.

 Paint the brown shadows on the red-acanthus stems and trumpet shapes.

9 Outline the gold areas with a mixture of black and burnt umber.

10 Highlight the blue areas with permanent white.

Thirteenth Century Border

• • •

No study of illuminated and illustrated capital letters is complete without considering borders. Their variety is as diverse as the different styles of lettering and ranges from a simple coloured line drawn down the margin, or between the columns of text, to almost a whole page of the most brilliant and complicated miniature and decorative work, with space allowed for only a word or two. How far you go on this path is up to your artistic inclination and ability, the time that you have to devote to the project and probably the depth of the your purse. The borders that I have used in this work are relatively simple, but also complicated enough to add great decorative effect to your work, and to give you great personal satisfaction when you have successfully completed them.

This example is from a thirteenth-century Book of Hours and includes a frame for a miniature picture. The original had the capital letter 'D', which I have included so that you can have some idea of the scale of such a letter, used in this way. You will see that there is very little room left for text and that this would have been confined to a few opening words or title and that the bulk would have appeared on the following pages.

The design is of the well known ivy leaf pattern and the leaves can be coloured green or any other colour of your choosing, or they can be gilded. You can mix them up, or you can use a different colour for the leaves on each of the branches.

In my project I have just used red, blue and green and have produced a solid and robust effect. You will see that I have applied white lines to the leaves and to the frame on the right hand side of the design. By comparing the two sides, you can see what a difference this makes and how that side looks much lighter and more sophisticated than the left hand. Both treatments have their place. The one that you use, depends on the effect that you wish to obtain.

Whether you paint a miniature in the frame, or use it to contain some significant text is up to you and the use to which the project will eventually be put.

It is worth remembering, that the original page was probably only 6 inches (150 centimetres) high and would have required the utmost patience and diligence to complete.

YOU WILL NEED

- ❖ Sharp 2H pencil
- ❖ Ruler
- ❖ T square/parallel motion
- ❖ Right-angled set square
- ❖ Project paper
- ❖ Tracing or greaseproof paper
- ❖ Gesso or PVA gilding medium
- ❖ Paper tube
- ❖ Gold leaf
- ❖ Gouache: gold and selected colours
- ❖ Brushes
- ❖ Burnisher

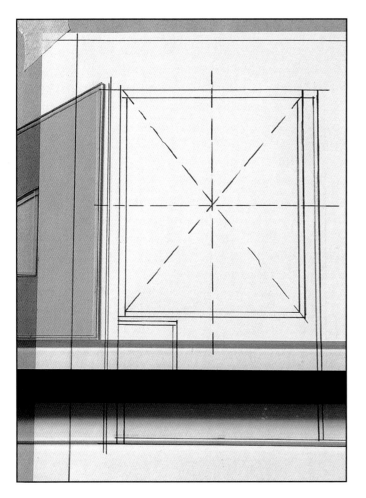

1 Draw the framework with a ruler and set square onto a piece of tracing or greaseproof paper. It is worth drawing it up in ink when you are satisfied, as it can be used at a later date, either as it is, or modified, for some other project. Draw it in a size that suits you and then use a photocopier to either enlarge or reduce it to the size needed for your project. (Remember that it is always worth drawing things bigger, if possible, and then reducing them down on a photocopier. This makes them look much neater and tighter.) When you are satisfied, trace your guide-lines down onto your paper, marking the centre and the diagonals with dotted lines. Clip the tracing to your project paper with paper clips, so that it does not slide about, and use a ruler to guide you, as you trace down. Once you have finished tracing down, do not use the ruler again. Do the rest of the work freehand. The little irregularities that will inevitably occur, despite your best efforts, help to give the project a natural spontaneity that is the mark of hand-done work.

2 Now within the guide-lines that you have traced onto your project paper, carefully draw up your scheme of decoration. You want to do this on a second piece of tracing paper, so that you can make any necessary corrections without messy erasures on your beautiful paper. If you do this, trace your finished design down onto your page. You should not need to draw over this; the traced outline should be sufficient.

3 Carefully stir up your PVA gilding medium. (If you roll it on the desk, you will mix it well without causing any air bubbles.) Paint all the areas you wish to have gold. One coat will be enough, but it does soak into the paper, and so if you wish the gold to appear slightly raised, you will need two coats. Each of these will take about thirty-five minutes to dry.

4 Take your paper tube and huff a warm breath onto a section to be gilded. It is important to do this before you apply any gouache paint, or you will find that your hot breath will also soften the gum in the gouache paint and the gold will stick to that as well. While the PVA is moistened and sticky, take a sheet of gold leaf and carefully lay it over the spot. Take your burnisher and rub the leaf, especially round the edges, so that it sticks to the form and peels off the backing paper. You can see through this, and so can tell when the gold has stuck down. You may need to apply another coat if your cover is less than satisfactory. The gold will stick to itself, as well as any uncovered patches of the gilding medium. With a little practise you will be able to place your gold leaf down on the page so that you waste hardly any of it.

Start at the top of the page and work your way down, so that you do not lean on any of the parts just gilded. When all is completed, take a piece of greaseproof paper, lay it on the work and burnish all the gold to raise a deep, lustrous shine. Finish off with a light burnishing directly onto the gold. Take particular care to work with the point of your burnisher round the edges of each form. From now on you, make sure that you have a piece of scrap paper between your hand and the work, so that you do not cause any damage to your completed work.

5 Take gold gouache and paint the four corners of the frame. When this is dry, you can burnish this to improve the shine, but the contrast between the paint and the gold is quite effective. You may find that you need two coats to obtain a satisfactory cover.

6 Carefully paint the border and the capital D with your choice of colours. I used two tones of blue. I mixed some ultramarine with some permanent white to make the pale blue and straight ultramarine to provide the darker tone.

7 With great care, do the outlining. The paint must be the right thickness. Too thin and it spreads and does not cover. Too thick and it blobs and will not spread and cover evenly. Usually, outlining is done with a mixture of black and burnt sienna, which makes a very dark brown. Too black and it looks severe. Too brown and it looks pale and anaemic. You could try a dark tone of each of the colours used. Green leaves outlined with dark green, and so on, reserving your black-brown outline for the gold areas. This is not as daunting as it may seem as you can do all the green bits, then all the red bits and so on.

8 You will need to decide how much you intend to highlight with white. This will depend on the effect that you seek and so I deliberately left some areas unhighlighted so that you can make up your own mind. You will also see that I have highlighted the leaves in different ways, some more, some less. This, too, will help you to decide what effects please you best.

Sixteenth Century Italian R

T his massive capital 'R' comes from a sixteenth-century book of Italian music. It contains two miniatures: one at the top and the second under the arch of the leg. At first sight this is a daunting project, but take it calmly, step by step, and it will gradually organise itself.

YOU WILL NEED

❖ Tracing paper

❖ Project paper

❖ 2H pencil

❖ Gouache paints: ultramarine, red, brilliant yellow, green, permanent white, Prussian blue, gold, burnt umber, black

❖ Brushes

1 Make a tracing of the main elements of the design and transfer it to your project page using a very sharp pencil.

2 Block in the colours one by one: first the blue, then the red and then the green, mixing each colour with a little white.

3 Paint the darker tones, taking each colour in turn. (Prussian blue made the very dark tone.)

4 Blend a little more white with each colour and paint the lighter tones. Where necessary, use a wet brush to blend the tones together.

5 Highlight the green areas with brilliant yellow.

6 Highlight the blue and red areas with white.

7 Paint the small gold areas.

8 Highlight the top of the ribbon with white and use a little burnt umber to shade the underside.

9 Outline the design with a mixture of black and burnt umber.

Fifteenth Century P

• • •

This project introduces the idea of writing the entire first word of the text within the capital, a concept that could have all kinds of applications. This example is based on a fifteenth-century model.

1 Make a tracing of the design and transfer it to your project paper. (If you want to modify the design, alter the tracing first.)

2 Mix the gesso with a little yellow ochre so that you can see it and apply it to the strapwork of the capital 'P', the doves on the finials and the letters that make up the word. You may want to lay on a second coat to raise it a little more.

3 When the gesso is dry, paint a thin coat of PVA gilding medium over it and leave it to dry.

4 Blow on the gilding medium through the paper tube and then apply the gold leaf using your burnisher. Start in the corner furthest from you and do a small bit at a time, making sure that you cover the medium well as you proceed.

5 Paint the blue areas using neat ultramarine.

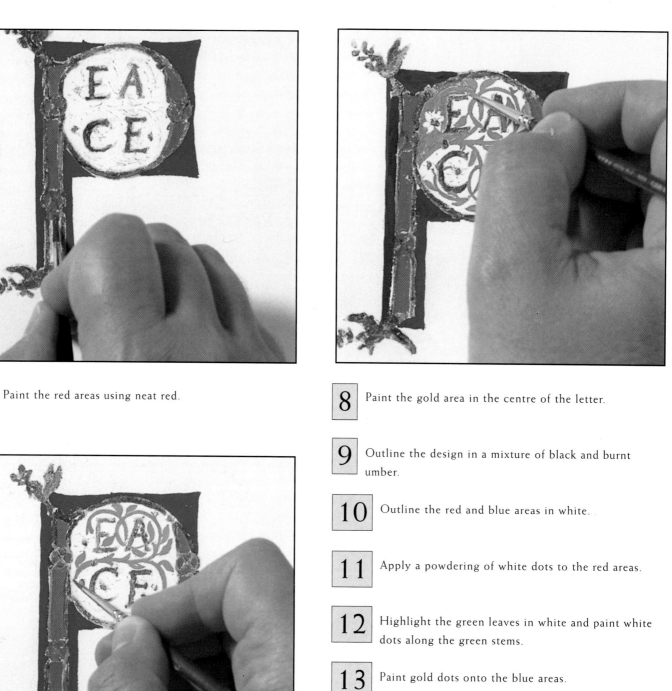

6 Paint the red areas using neat red.

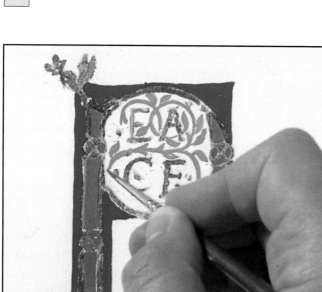

7 Paint the green areas with a mixture of brilliant yellow, ultramarine and white.

8 Paint the gold area in the centre of the letter.

9 Outline the design in a mixture of black and burnt umber.

10 Outline the red and blue areas in white.

11 Apply a powdering of white dots to the red areas.

12 Highlight the green leaves in white and paint white dots along the green stems.

13 Paint gold dots onto the blue areas.

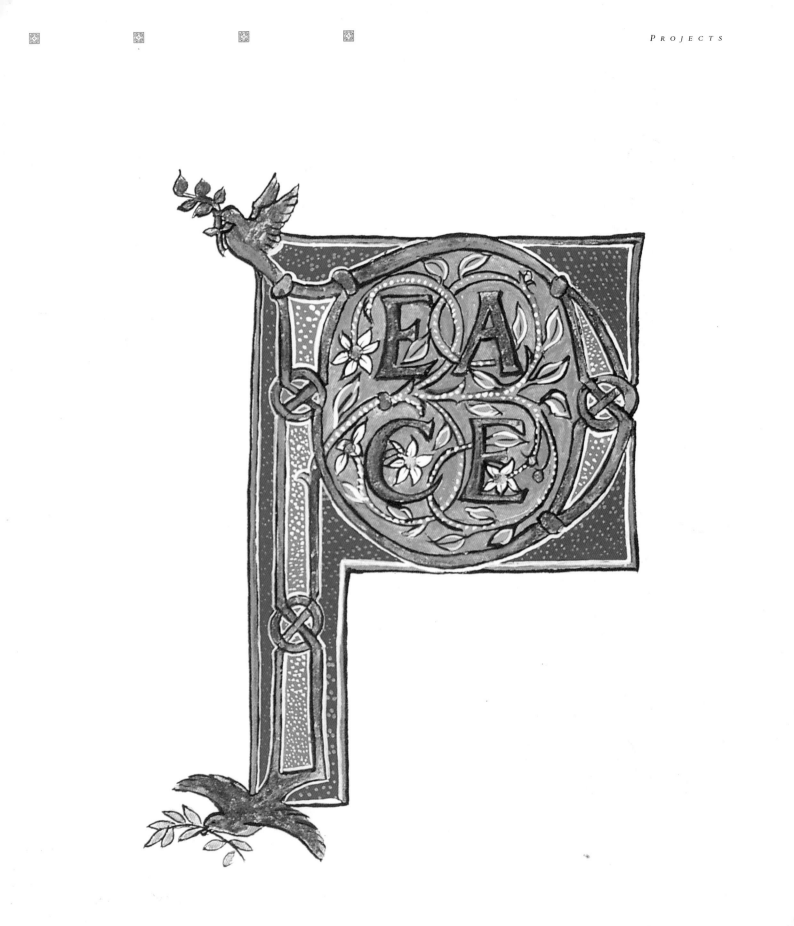

Fifteenth Century W

• ◆ •

This 'W' was copied from a fifteenth-century manuscript and was originally an 'M'. I traced the letter and then turned the tracing paper upside down and traced the decoration, adapting it as necessary. This kind of adaptation will help you enormously if you can not find the exact letter or style of decoration needed.

I painted the letter using light and dark tones on all the colours, which adds greatly to the richness. It is highlighted in white and outlined in a mixture of black and dark umber.

Notice that I have drawn the bottom right-hand point of the gold square outwards a little to give it more style and take the plainness out of the straight line.

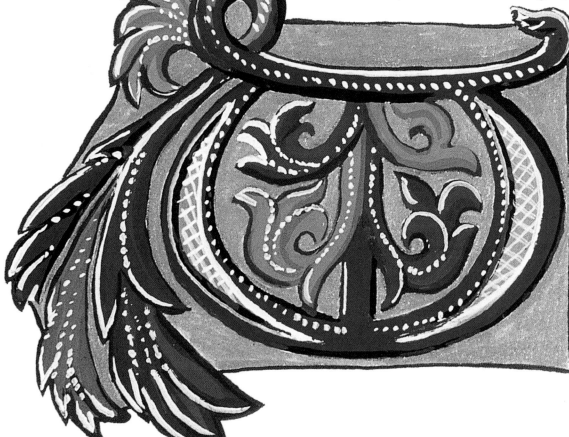

Fifteenth Century W

• • •

This impressive capital W was developed from a fifteenth century capital M. It was drawn free-hand from the example, the different elements being reversed as necessary. The muted colours give it a subdued dignity, which is extremely attractive.

1 Take a careful tracing. Note that the black centre is not symmetrical. You can leave it as it is or you can correct it in the tracing. The tail has a tendency to drift to the right and would look stronger if it were straighter. Correct this as you trace it.

Rule a grid on your tracing paper to contain the stem and the shape of the capital. Also rule a cross through the middle of the letter, on your tracing paper. You will quickly see which parts you need to alter. As you trace it off, move the tracing paper about, so that the part you are tracing is correctly located in the grid that you have drawn. Thus, when you have finished the whole will be correctly located on your tracing paper and you will be able to trace it down onto your project paper with every part located in the right place.

 2 I chose to paint the green areas first as this seemed to be the predominant colour. Mix up some yellow ochre and ultramarine .Carefully paint the green. Mix in a little white and paint the light tones.

 3 Mix a little ultramarine with a little white and dull it down with a little of the green mixture. Paint the blue elements. Add a little more white and paint the lighter parts.

 4 Similarly paint the red with madder carmine and then mix in a little white to paint the lighter parts

 5 Paint the black with a 0000 brush. Take care to work neatly, using it to tidy up and delineate the green leaves and the gold elements in the centre.

 6 Take some of your green mix, add a very little black and use this to paint the inside of the letter.

 7 Highlight with white lines and dots.

 8 Enliven the dark green background colour in the middle of the letter with gold dots. Notice that they are placed in threes.

9 Paint the rest of the gold areas.

10 Outline with a mix of black and burnt umber.

Simple floral treatments

◆ ◆ ◆

These little examples have been drawn to show how effective simple flower decorations can be. They have been drawn in ink and painted with watercolour. Because this is transparent the pen line shows through and there is no need to outline. Were they painted with gouache, which masks the pen line, they would have to have outlines to neaten and tighten them up. They would however look brighter and more jewellike. The letters would have looked better had they been outlined with paint, but they point out the folly of trying to outline in pen more eloquently than a written warning.

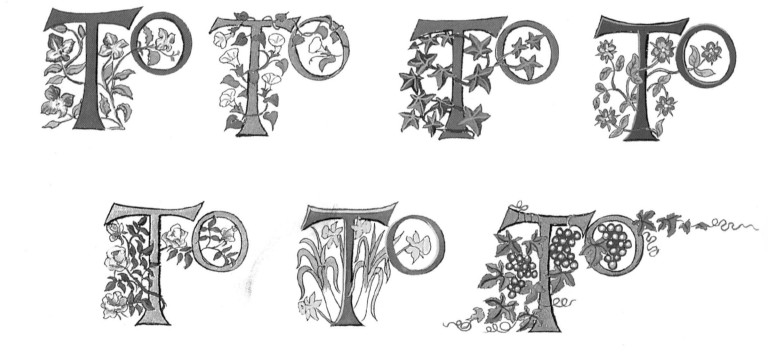

Sixteenth Century Border

• • •

This border is an adaptation of the ivy-leaf pattern. The miniature was copied from one by the Italian master Guilio Clovio, who worked in the first half of the sixteenth century. He is regarded as the Michaelangelo of miniature painting, one of the finest illustrators of manuscripts who has ever lived. His borders typically contain classical figures, armour, architectural features, urns and diverse decoration, all delicately and excellently drawn and coloured. I have added the birds and creatures both to signify creation and to add some colour and interest.

TIP

DRAFTING YOUR DESIGN

When you embark on a project, it is important to consider the text and the decoration together, so that you do not spend hours on one part only to find that you have created an irreconcilable conflict with the other. The size of the miniature, the disposition of the frame and the location of the little box for the capital letter will be determined by the length of the text. Experiment with drawing draft shapes and layouts on a piece of rough paper. Keep all your drafts: if they have not worked for this project, they may well help you with another. Do not be afraid to try something new. Learn from the past, but develop that knowledge.

Templates

◆ ◆ ◆

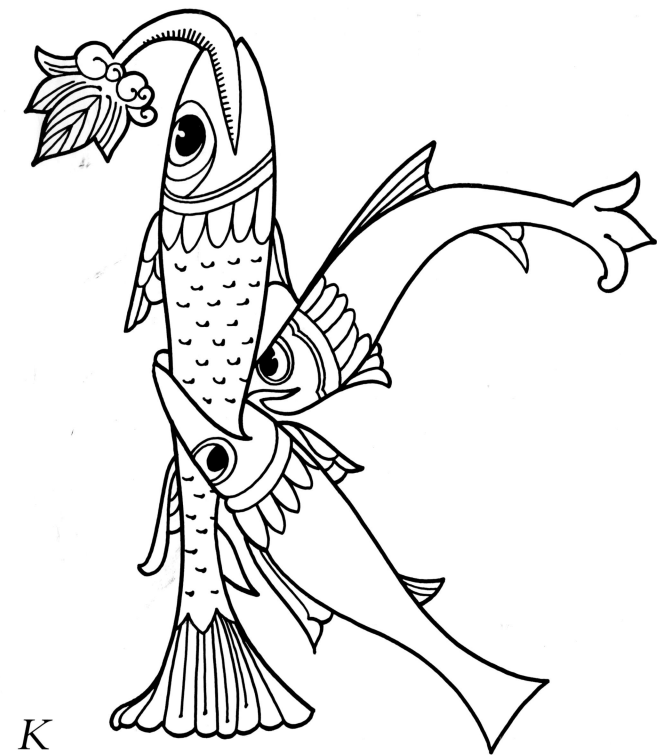

K

Templates

◆ ◆ ◆

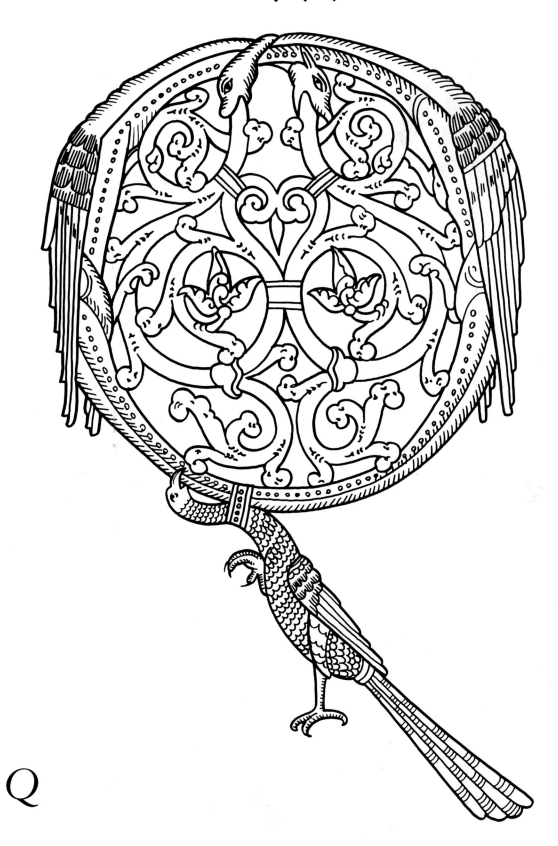

Q

Templates

∙ ∙ ∙

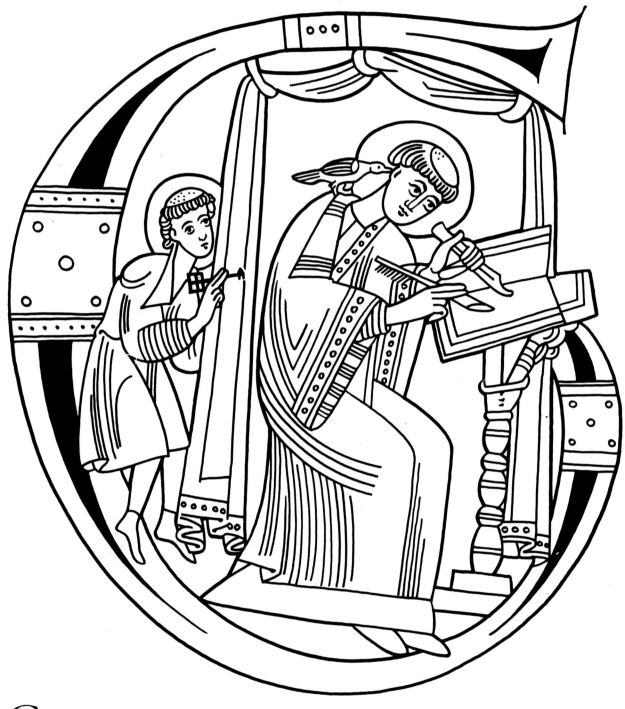

G

Templates

◆ ◆ ◆

E

Glossary

◆ ◆ ◆

Ascender
In calligraphy, the stroke which ascends above the height of the lower-case letters.

Base
The medium used to adhere loose gold onto vellum or paper – gesso, size. or P.V.A.

Bestiary
A natural-history book, popular in the twelfth and thirteenth centuries, containing tales about animals, both real and imaginary.

Burnish
To polish or shine. In illumination, a burnisher *(see below)* is used on the gold to achieve maximum reflectivity and smoothness.

Burnisher
A smooth-ended tool, formerly a dogtooth or agate, now made of hard, smooth plastic or mineral.

Carpet page
Ornamental page of decoration, often cross-shaped, found in Celtic gospels.

Cursive
Informal style of script, with the letters linked. Used for letters and documents rather than manuscripts.

Descender
In calligraphy, a stroke which carries on below the height of the lower-case letters.

Diaper
To decorate with a small, uniform pattern – often used for the background to a scene or in the depiction of drapery.

Gesso
A mix of fine plaster and adhesive, which is used as a base to bind loose gold to the support in raised gilding.

Gloss
A commentary written alongside a text.

Gouache
Water-based, opaque paint often used in contemporary illumination instead of traditional tempera.

Gum arabic
A type of gum, added to powdered gold as a binder.

Gum ammoniac
A resin, purchased in crystal form, which is melted down with hot water to make size, the traditional base for flat gilding.

Gum sandarac
A resin used as a fine powder in the preparation of vellum for calligraphy and illumination.

Half uncial
A script using ascenders and descenders with the pen held at a slanted angle.

Historiated initial
An illuminated initial where the void of the letter is painted with a scene relevant to the passage it heads.

Insular
Refers to work produced in the British Isles c.550–900.

Interlace
A type of pattern where several lines or bands are plaited over and under each other.

Loose gold
Gold beaten into delicate, fine sheets, applied to a base in gilding.

Majuscule
Upper-case script.

Minuscule
Lower-case script incorporating ascenders and descenders.

Papyrus
Earliest form of support (*see right*), made from the stem of the papyrus plant.

Parchment
Sheep- or goatskin prepared to make a delicate support for calligraphy and illumination.

Pounce
A fine, abrasive powder which is used to prepare vellum for calligraphy.

Powder gold
Pure gold, sold by the gram, which has been ground to a powder. It is mixed with gum arabic and used for illumination.

P.V.A.
Polyvinyl acetate glue, which can be used as a base for raised gilding.

Rubrication
To emphasize part of the text in red. It is used in this book to describe the application of rows of red dots around the outline of illuminated letters in the insular style.

Serif
The strokes which end the main strokes of a letter, sometimes wedged or hooked.

Shell gold
Powder gold combined with gum arabic and allowed to harden in a pan (originally sold in a half mussel shell).

Size
Traditional base for flat gilding.

Support
The material used as a surface for calligraphy and illumination – paper, vellum, and parchment.

Tempera
A medium consisting of ground pigment and egg yolk, diluted with water.

Transfer gold
Sheets of gold manufactured as a transfer (i.e., with a backing sheet).

Trompe l'oeil
An illusionistic representation of a subject on the two-dimensional page which deceives the eye into thinking that it is three dimensional.

Uncial
A script used in manuscript writing by the Romans and Celtic peoples, such as Celtic uncial.

Vellum
Calfskin that has been prepared for calligraphy and illumination.

Versal
A capital letter from an alphabet of Romanesque origin, so called because it was used to plot the opening of a new verse.

Index

♦ ♦ ♦

CREDITS
Winchester Cathedral, Hampshire/Bridgeman Art Library, London/New York
 p.14 Initial letter 'P' Prevaricatus Moab – The Moab Rebelled, II Kings: illustration shows Elijah intercepting the messengers sent by King Ahaziah, from the Winchester Bible (c.1150–80).
 p16 Initial letter 'V' Visio Abdie – The Vision of Obadiah: illustration shows Obadiah of I Kings 18, v4 from the Winchester Bible, (c.1150–80).

Project artwork and calligraphy by Stefan Oliver
Photography by Nigel Bradley

Additional illustrations by Rob Shone